AND THEN CAME THE LIBERATORS

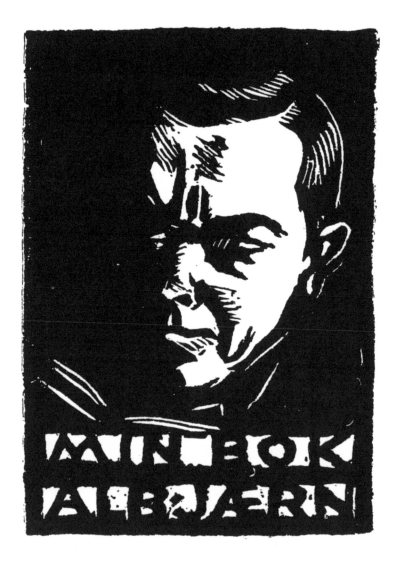
MIN BOK
ALBJÆRN

AND THEN CAME THE LIBERATORS

ALBERT JÆRN

Translated from the Norwegian
by Solveig Schavland

With an Afterword
by Kathleen Stokker

Edited by Richard Quinney

BORDERLAND BOOKS

Borderland Books Edition ©2011
Translation ©2011 by Solveig Schavland
Afterword ©2011 by Kathleen Stokker

Published by Borderland Books, Madison, WI
www.borderlandbooks.net

This translation has been published with the financial support of NORLA, Norwegian Literature Abroad. A copyright holder for the original Norwegian book has not been found. Borderland Books should be contacted for royalties if a copyright holder can be established.

We thank David Nute and Carol and Lee Bjerke for introducing us to the original Norwegian edition of this book.

Publisher's Cataloging-In-Publication Data

Jaern, Albert.

[Og så kom befrierne]

And then came the liberators /Albert Jærn; translated from the Norwegian by Solveig Schavland; with an afterword by Kathleen Stokker; edited by Richard Quinney.

Translation of: Og så kom befrierne.

First published as: *Og så kom befrierne: utdrag av min dagbok gjennom 5 år.* Norway: Ekko, 1945.

ISBN: 978-0-9815620-7-0

1. World War, 1939–1945—Personal narratives, Norwegian.
2. Jaern, Albert. I. Schavland, Solveig Astrid, 1940–
II. Stokker, Kathleen, 1946– III. Quinney, Richard. IV. Title.
V. Title: Og så kom befrierne.

D811.5 .J3413 2011

940.5481/481 2010908315

Printed in the United States of America

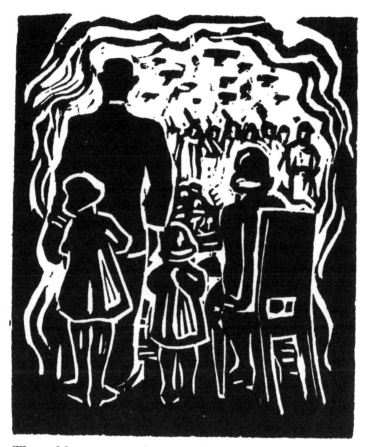

The table was set when the Germans came.

FOREWORD

When I started to work on these woodcuts, which would give a small picture of wartime in Norway as I experienced it, I did not think about making a book. Actually I meant to write a letter to relatives and friends in Sweden and America, since it was an easier way for me to "write." But as I continued with my work, some of my friends saw it and asked me to print enough copies of the "letter" that they could also have one. So it ended up that I printed 200 numbered copies of which most were sold before the end of the war. The book came out on the seventeenth of May 1945 — and later Ekko Forlag asked if they could publish the "letter" in regular book form.

This book is about me and mine during the war years but that is the way it had to be. Only in this way and no other way could I write about what had happened. But I believe that most people here

have experienced something similar, and therefore I hope that this journal can serve as a journal for many others. Most of all, I hope that the younger generation will find something that they will always remember about tyranny and oppression. We must never forget what happened. It could happen that one or another crazy person would want to start a war again ...

Albert Jærn

April 8, 1940. My wife and I were sitting in a café in the center of town at eleven-thirty in the evening. Suddenly all the lights went out.

We walked and stumbled on the way home, and the only light we saw was in some of the windows in the German consulate ... The invasion had begun.

1

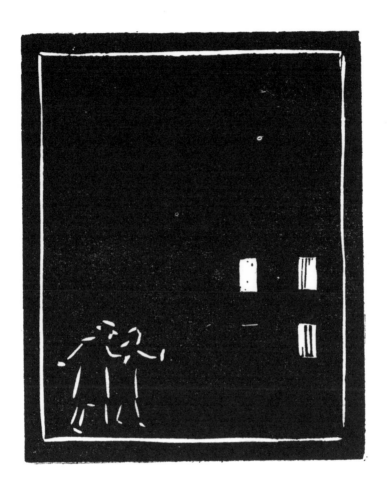

April 9. At six o'clock in the morning I saw for the first time a plane falling from the sky. It was over Fornebu airport.

2

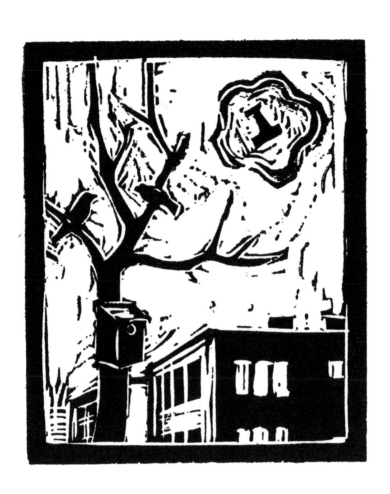

April 9. When I came down to Stortings Street, the Germans were confiscating automobiles. I went around the corner and got away.

3

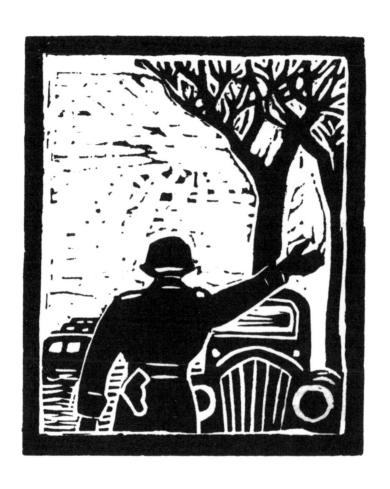

April 9. I made three trips with the elderly and children to the Østbanen railroad station. Afterwards I went to Hadeland. I had 45 liters of gasoline and 1,65 kroner in my pocket, so I was worried if I would make it back home again.

April 10. Started from Oslo at seven in the morning with my wife, two daughters, and a son-in-law, along with two dogs, Store Tass and Lille Tass. When we got to Grua some young people stopped us, wanting to know if we had any news. When one of them asked if we had seen any Germans, both dogs jumped up full of rage and it was difficult to quiet them down.

4

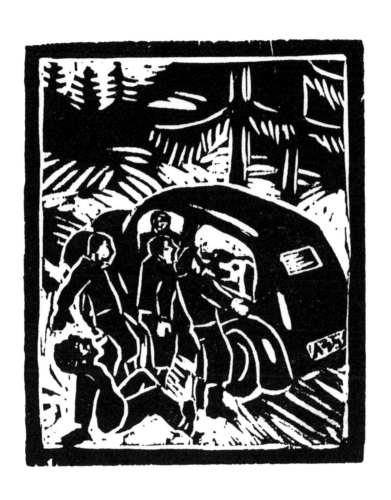

April 10. People were so overcome with panic that they took the coffin out of a hearse and placed it on the sidewalk outside the Handelsbygningen so they could flee in the hearse.

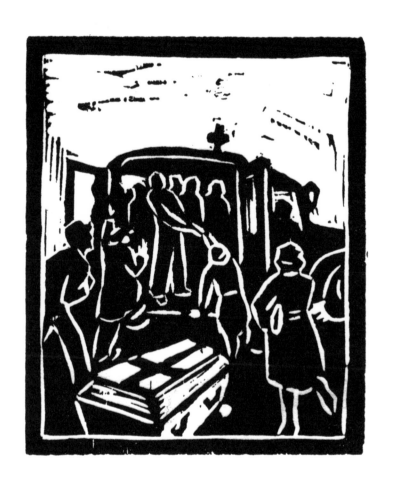

Thousands of people fled in automobiles because of rumors that Oslo was to be bombed. But the truth was that the Germans wanted to bring ashore the corpses from the *Blücher,* which had been sunk outside of Drøbak.

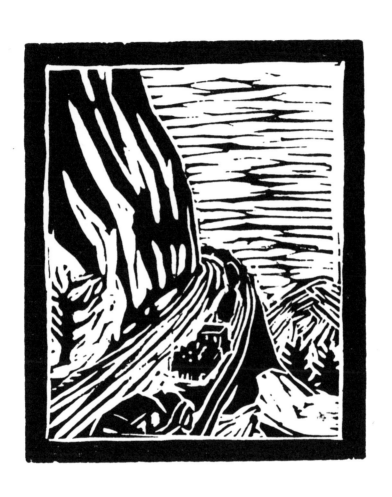

April 11. In Jaren a horse came galloping with a boy on its back. The boy yelled that the farmers had gathered to meet the Germans that were coming on the road from Ringerike. They were only two miles away.

The farmers gathered with scythes, axes, spades, and pitchforks. These were the weapons that they had to fight the Germans with.

7

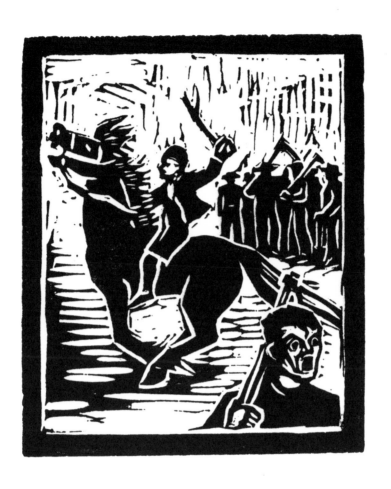

In Haugsbygda forty-eight farms were burned. The livestock that were saved stood in snow up to their bellies.

8

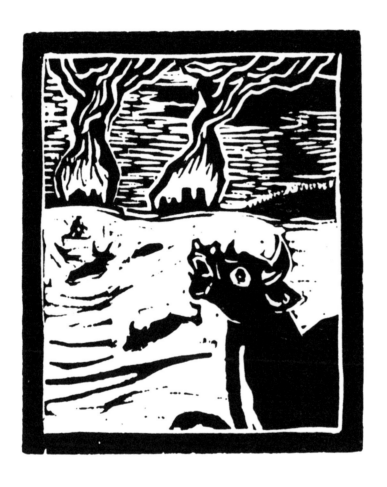

This morning our boys left here and went north. They were in good humor. They said that in four hours they would be in German-occupied territory.

 9

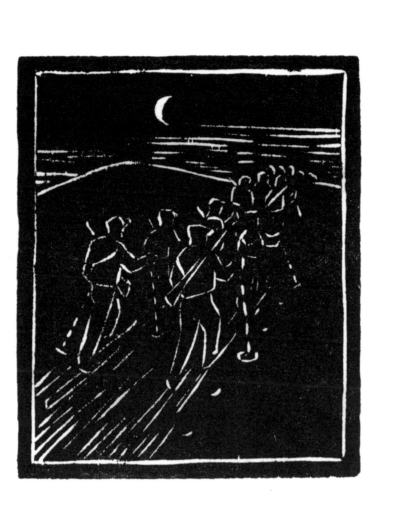

In Brandbu a young German soldier on a woman's bicycle came over to us and asked directions to Brandbu. He was sent on his way to Gran, and if he bicycles fast, he should be back here in about three to four hours.

10

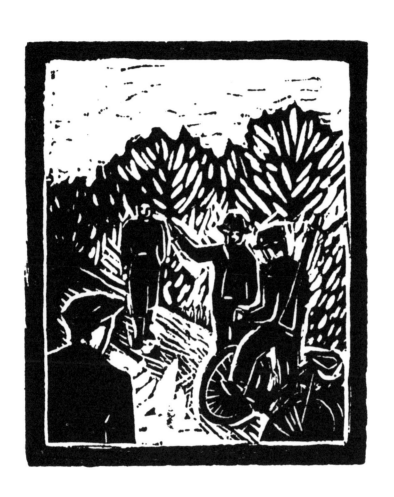

There were fourteen Jews on the neighboring farm. All day long Aron and Simon and Apraham brought groceries back from the country store.

There was enough money, because the Germans bought everything that was in the confectionary stores in Oslo and Drammen.

We were short of money, but still we got what we needed from the farmer at Alm, and he did not want my daughter's bankbook for security.

11

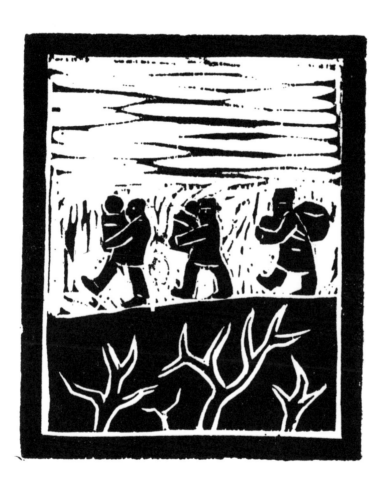

Day and night the planes flew in an easterly direction toward Elverum carrying troops. Today the radio transmitter must have gotten a direct hit, because suddenly it was silenced with a pop.

12

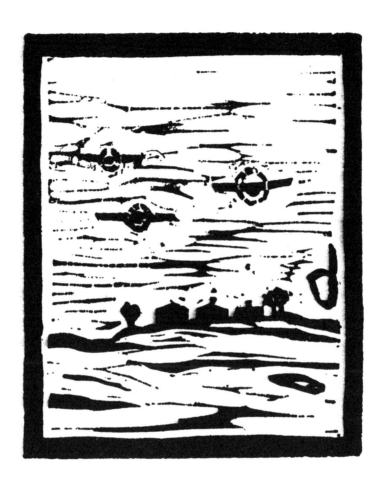

We listen to London late and early. Promises from London and threats from Oslo. Today a Swedish lecturer in London said that in eight days there would not be a single German left in Norway — they are in Gudbrandsdalen now.

13

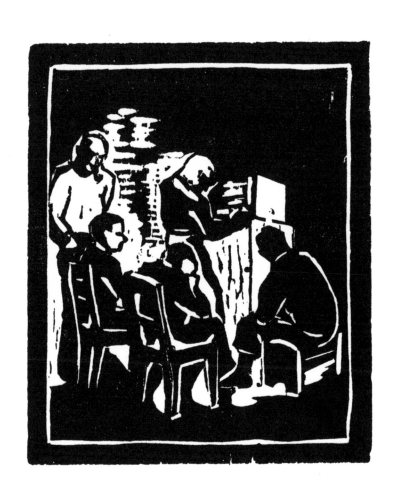

The forest in Stryken was sad looking after the fighting stopped. The tree-stumps were about one meter high.

14

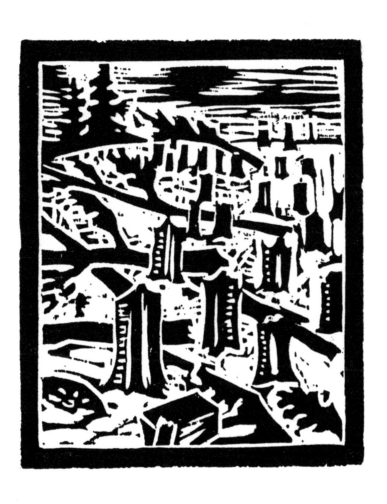

April 30. Today we came home after the evacuation. There are Germans everywhere, and they eat chocolate with a thick layer of butter on it.

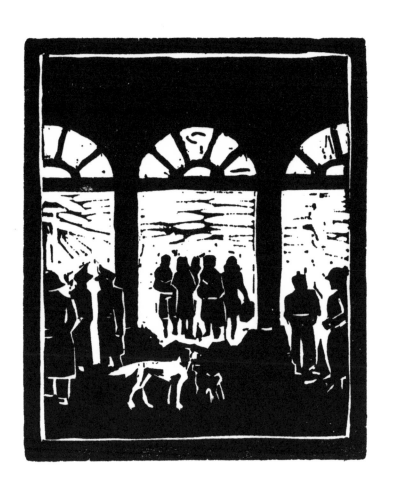

There are absolutely no potatoes here in the city, and when I received ten liters of gasoline to bring the car home from Brandbu, I decided to load it up with potatoes. But the radio said it was forbidden to take potatoes out of Hadeland. So I called the supplier and told them my plan, which was approved, almost applauded (they must not have been listening to the radio). I came to Oslo with 650 kilos of potatoes that were sold to neighbors at top price, and I earned 32 kroner for the job—first earnings in a long time. I have become a merchant—dealing in potatoes.

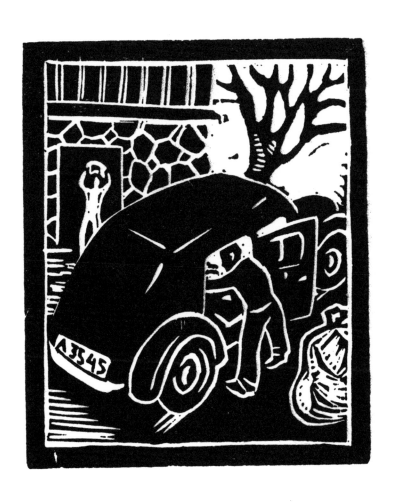

It was not only Apraham and the others who brought something home. Those who had money bought what they needed. I asked one of my connections if he had any work for me, but he answered that he had little work, just from hand to mouth. He is a millionaire. During that time I earned 70 kroner in seven weeks.

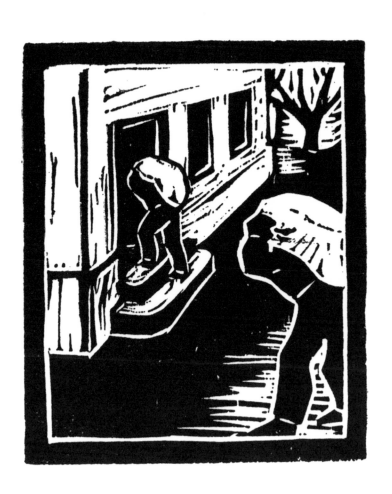

We old friends have to stop meeting at the café. Since the old half-crazed pharmacist came here, we can be arrested at any time because he continually rants and raves that we are communists and sympathetic to England. But today when I met him, I told him that I had seen his daughter with a German ... That got to him.

The old meddler wanted to teach us some manners, he that could not even teach his own daughter how to behave.

18

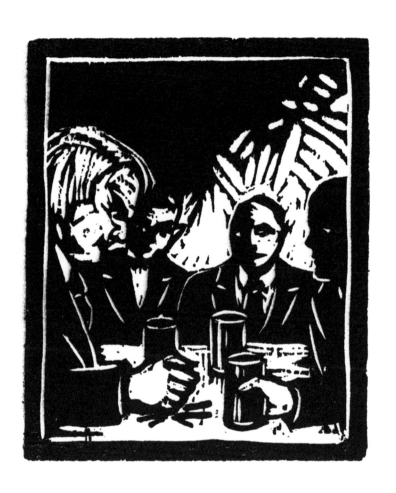

It was a full house at the café. The new manager greeted the new guests with a Hitler salute.

Is he afraid that we will not get rid of our goods?

19

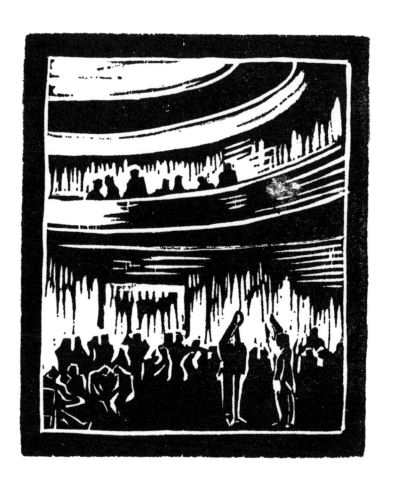

Outside of "Löwenbräu" a German asked me about an address. I answered, "Don't know," and the German became livid and yelled after me: "Don't understand, don't know, can't"—but then I don't know German! I think these are the Norwegian words that the Germans learned first.

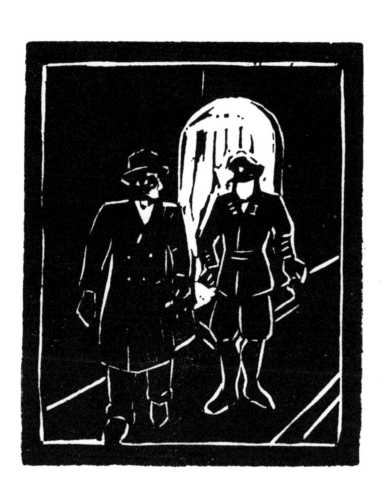

There is order in the community today.

A laborer with many children was in court today because he traded his liquor ration-card for bread. The man was fined. We can't even choose which rationed groceries we want.

 21

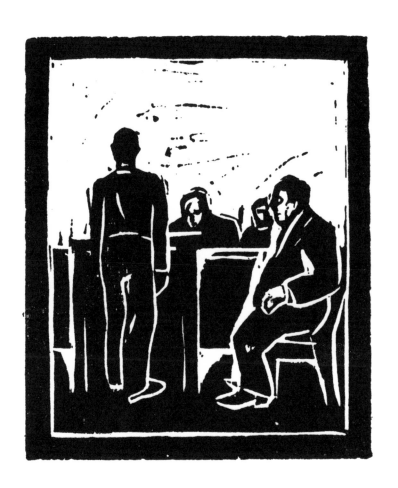

France has fallen!

"Think of the power that the Germans have," people are saying. There is no one saying: "Look at the crime." But we live in hope.

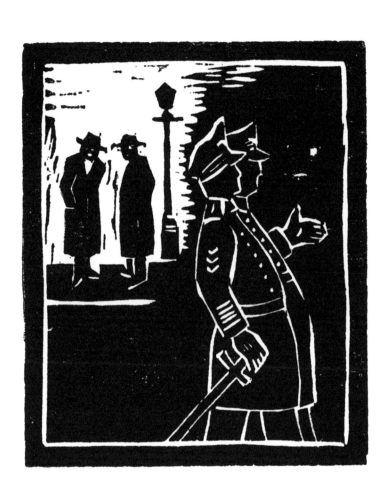

Summer 1941. Today my wife had another visit from Mr. "Jo" from Kristiansand. He has been here two times, each time when I have been on a quick errand to town. He is a friend of our neighbor, who is right now on vacation, he tells us. Jo said that our neighbor is living with his father in Kristiansand during his vacation. But I know for certain that our neighbor has never been to Kristiansand.

Now Jo is asking for help. He tells us that he has been in a German prison for two years, that his father has been sentenced to eight years, and that his brother has been shot. And to be certain of pity came the raisin in the sausage: His wife had run away with a German. I came home and got a glimpse as he left. Not too bad to look at, but he had a limp.

23

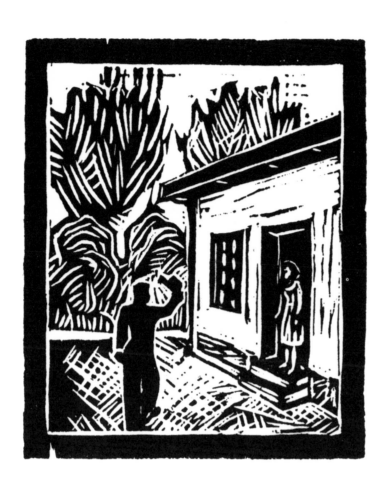

The Germans started to requisition radios, backpacks, then woolen blankets, automobiles, airplanes, motorcycles, and rubber boots. During home inspections they have helped themselves to silverware, food, clothing, and money. *Aftenposten* reported that we could not expect the Germans to wage a war in Russia without what they needed from us.

We did not ask them to wage war against anyone ...

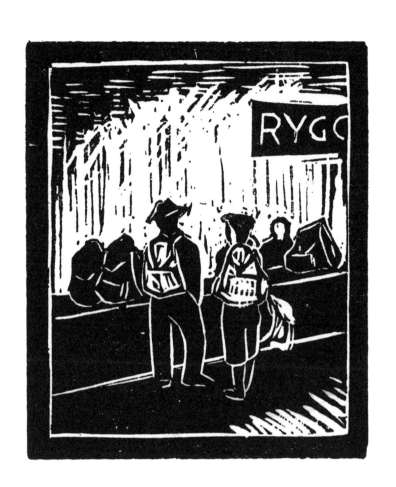

When the Germans needed metal, all coins were to be confiscated. I filled two milk bottles with nickel and copper coins and buried them in the yard.

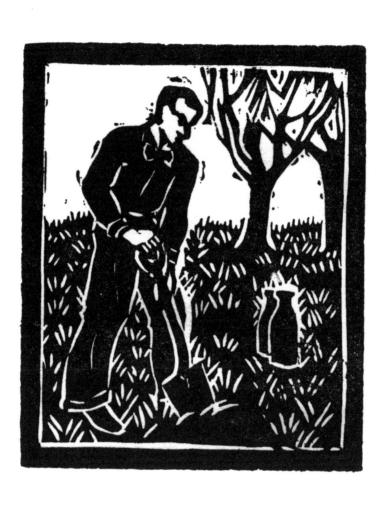

Many have already been shot by now, but the disgraceful murders at Hansteen and Wikstrøm cannot possibly be surpassed.

26

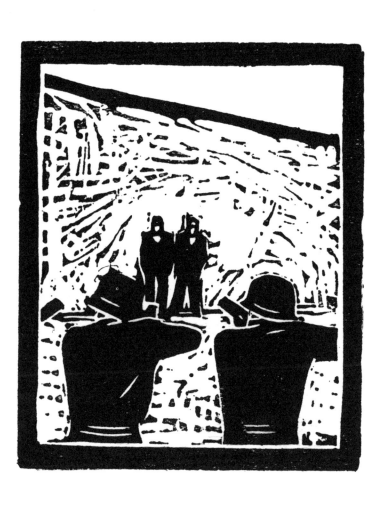

This evening I went to the movies, but I felt that as a civilian I could be arrested because of all the police guards that were present.

The program started with a UFA week review of German war propaganda, unfortunately not noted on the program. Then the people began to cough. I didn't think it was unusual because it was midwinter, when most people more or less have colds. The show was stopped. The police said it was a demonstration, and they emptied the theater. It's common for people to be punished through their pocketbook.

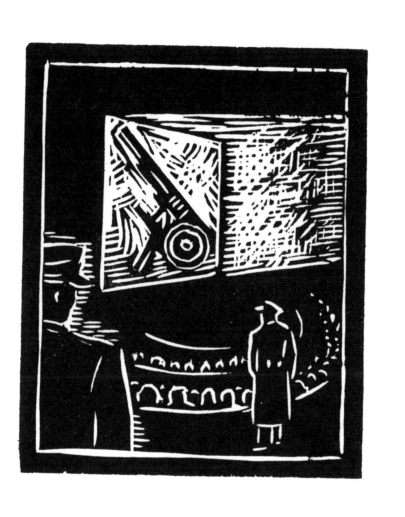

"Herrefolket" select their homes from ours, and everything they touch they defile. There isn't one of these houses that has not been defaced. It will take years to get them fit for use again.

28

"Kulturfolket" show little civility when it involves someone else's property. They recline in the parlor chairs that belong to the villa that they have confiscated, and sunbathe.

The Germans could not possibly have seen furniture before they came here.

Today when I arrived at Foss School to start teaching, there were police guards.

One of the teachers had been attacked and sent to the hospital—something like that has happened before. The attacker came in an automobile ... so it must have been organized.

30

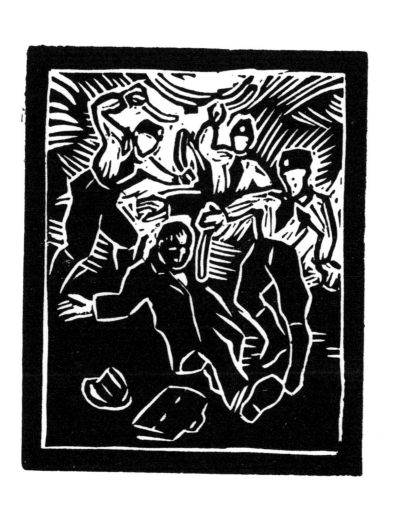

The nighttime offensive is a beautiful sight, with colored rockets, flares, and silver planes. But not completely safe to behold.

31

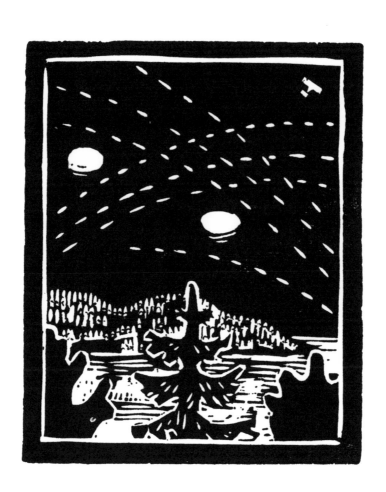

Many rare scenes are acted out in the evacuation shelter. Often it is almost better to be above ground. And when the alarm lasts for many hours it can get very cold and the air gets bad down there.

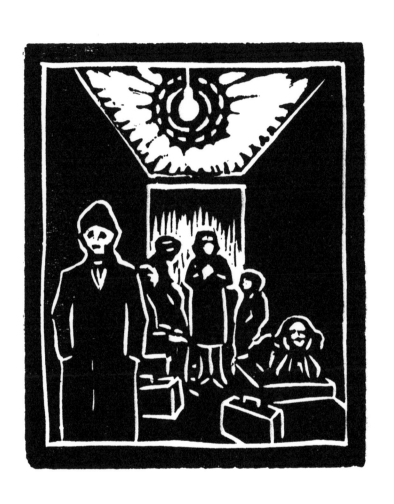

Seventeenth of May, by the Ibsen statue outside of the National Theatre. A cultural leader does not need a uniform to assert himself.

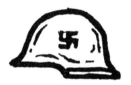

33

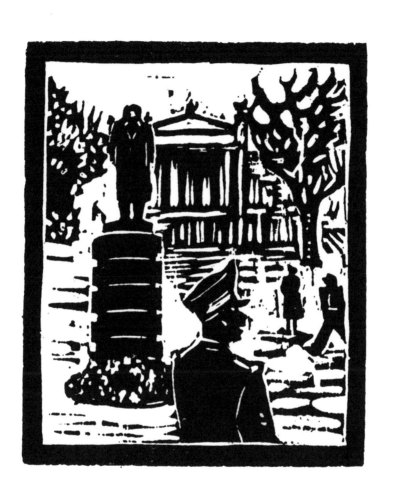

School strike. Many more teachers than students showed up today. The three strikebreakers there, quarreled.

34

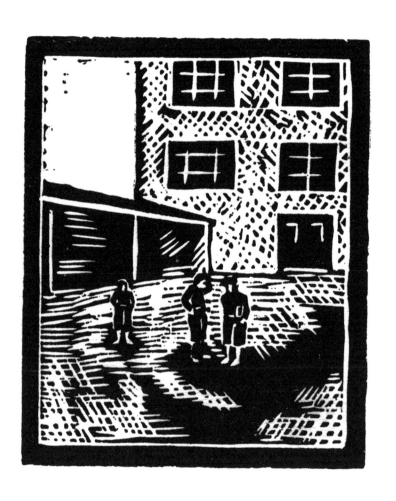

When the *hyrden* of these new times give their sermons, not many of the flock come to church.

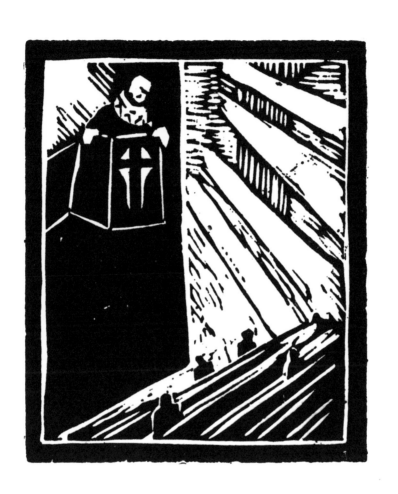

November 6, 1941. I went on a bender yesterday because I couldn't stand to stay home — Store Tass was put down, because we could not get proper food for him. Our dear, dear "Tassen."

We were also afraid that the Germans would use him to walk through the minefields.

36

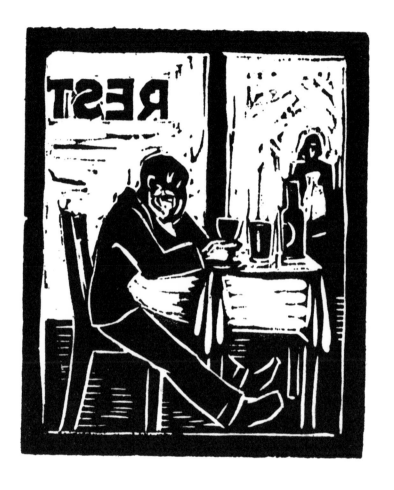

There is no class difference when it comes to the cigarette stub. The quickest becomes the owner, or in the worst case the strongest becomes the owner.

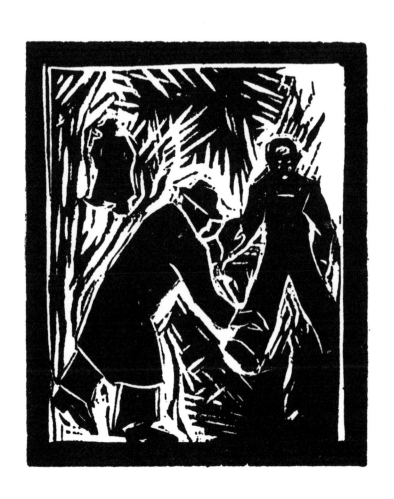

After "the German *kulturfolk*" occupied the country, all education became primitive. Banks, businesses, and religious meetinghouses are used as schools.

38

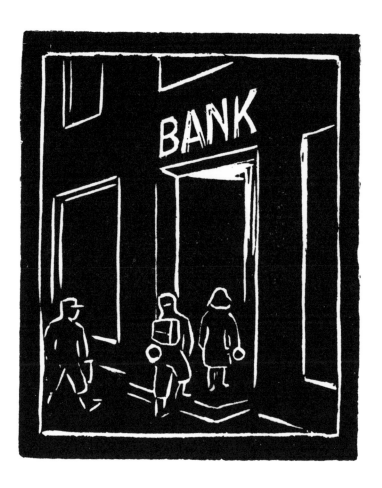

The greatest benefit the children have from going to school is the food from *Svenska Norgeshjälpen.*

39

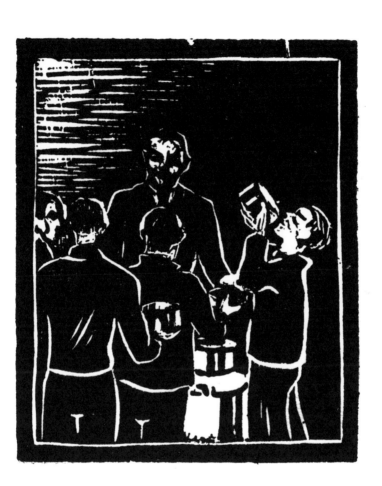

That people stand in line I can understand, but in a line for fish, I do not understand. Now the whole city has eaten lutefish, without butter, for three months. Sometimes there are maggots in the fish that we stand in line for. We have not been rationed any meat in over six months, and we have to have something to eat.

I am glad that I eat very little.

40

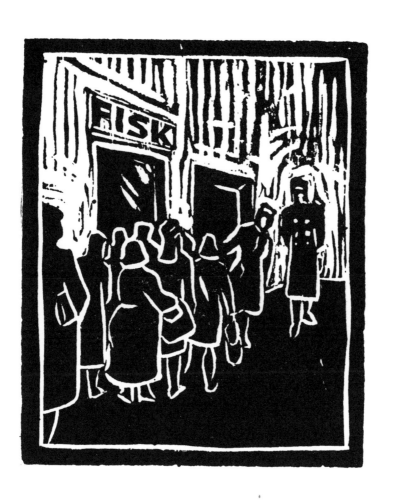

I was arrested at the home of a friend on June 20, 1941. Meanwhile, my house was being searched and my wife was interrogated. The *Statspolitiet* asked her, among other things, if we often received newspapers. She answered, "Yes, but not as often as before." The officer asked what papers they were, and she answered, *"Fritt Folk* and *Norsk Arbeidsliv."* They are the Nazi publications, which the florist uses for wrapping paper—probably where most of them end up.

41

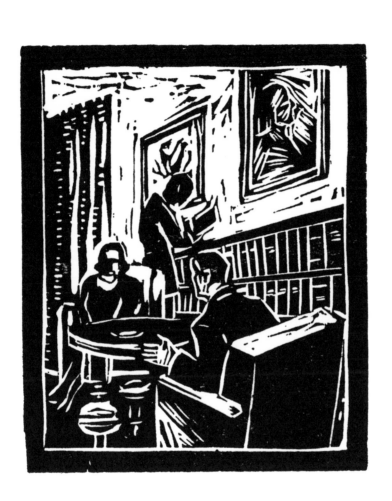

During the interrogation, my daughter Brit came to the door and said in her most casual-sounding voice, "I am going for a walk with Gerd." Brit took with her the latest news for safekeeping.

42

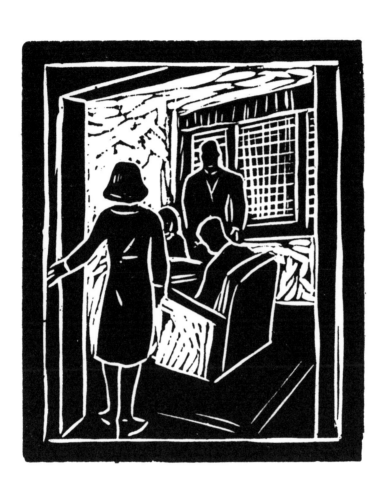

After three interrogations that lasted for four hours, I was driven to the Nazi prison Bretvedt in Grorud along with a woman and a friend of mine. It was a strange feeling to be in a room that had a door without a doorknob, just a completely plain door. Still, the worst part of a room like this is the "pail."

The literature that was delivered to me was an old, dear book, *Oil* by Upton Sinclair. I reread the book, and certain words had been underlined with a fingernail. Likeminded others have sat here before me.

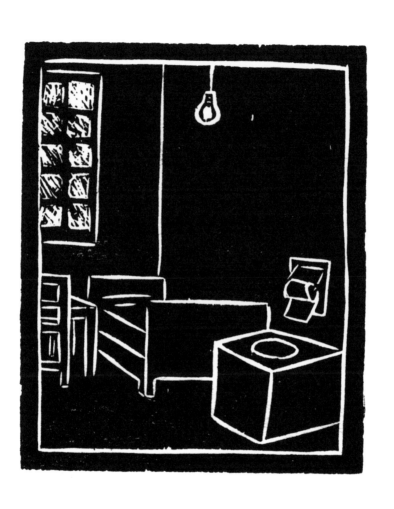

I was released after a few days, but was sent to the city without papers or money. I had to call a restaurant where they knew me so I could get a little food. My wife and I went down to Jaquet and ate beef stew and received a bottle of champagne.

A day later I went in to pay my bill. It was 23 kroner. It is inexpensive to live when one has been locked up.

At home, an eleven-pound salmon was waiting for me.

 44

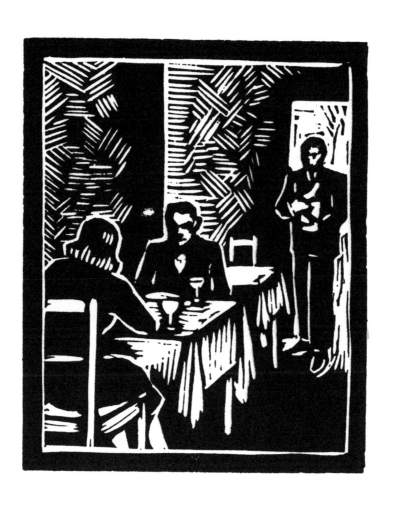

Today Agent Lindvik from the *Statspolitiet* was shot. He was present at my three interrogations. A few days ago two automobiles coming from opposite directions on Karl Johan Street honked several times as they passed each other. Afterwards a man in a German uniform was lying on the sidewalk. No one had heard the shots.

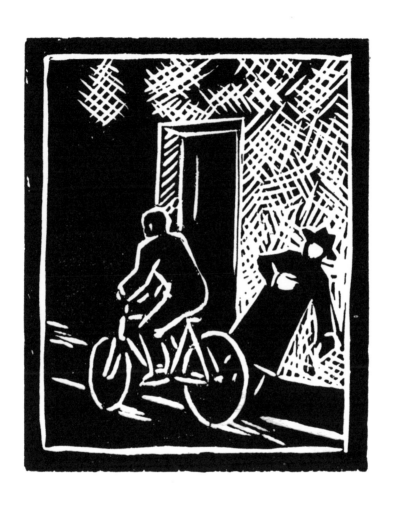

On the Holmenkoll trolley the Norwegian passen-
gers were threatened if they refused to sit next to
a German—but people would rather stand ...

46

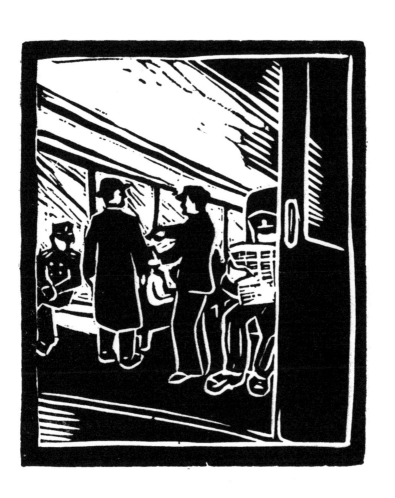

August 3, 1941, the King's birthday. Today at the market, the police were clearing the place because a female vendor was selling "beautiful teasing flowers" in support of the King. Outside of the Continental many people were arrested because they had teasing flowers. They received a fine of 50 to 100 kroner. The detainee came back later with a receipt for the paid fine. Many had been fined double of what the receipt said. It was a day of great celebration in town. And the statue of Christian Qvart stands and declares, "This will be the location of the city."

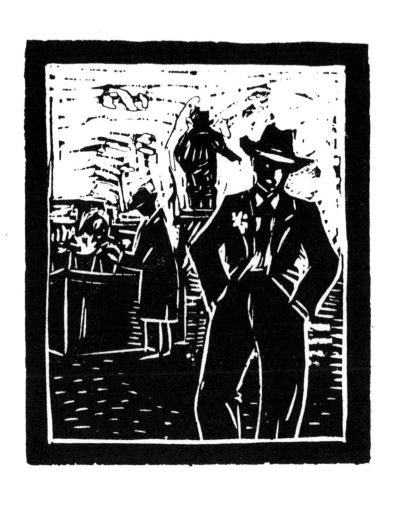

The Germans have introduced a clearing system, and will put it into effect for all the people. We call it *"svartebørs."* A pair of old boots is the same as 4 kilos of geitost, a bottle of Borger Akevitt is the same as 1 kilo of butter. Before, we could buy 2 kilos of butter on the black market for 50 to 60 kroner per kilo, but now it is completely impossible to get any money.

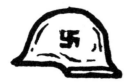

48

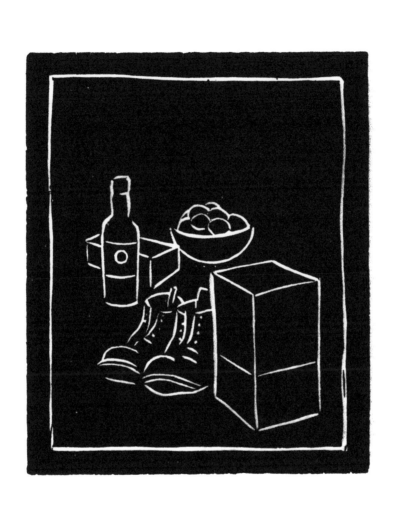

Without the black market I doubt that we could have stayed alive. It is expensive, but when I have enough to do and earnings are good, I can purchase what is necessary. There is nothing else to buy, so what better than to spend your money on your health. Price list December 1944:

– Butter 60 kroner per kilo, but difficult to get, so the price increases greatly.

– Sugar not listed, because there is none. Flour 20 kroner per kilo.

– Geitost 40–60 kroner per kilo. Pork 40–50 kroner per kilo.

– Eggs 40 kroner per 10. Coffee 500 kroner per kilo.

– Cigarettes 1–15 kroner for one 10-pack.

But the worst is that the Germans can increase the prices of all our goods to the maximum.

49

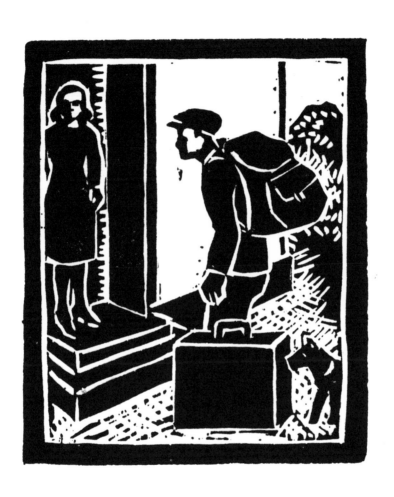

Today the German police again surrounded a city block and picked up some men. I hope that they don't receive the same fate as the students, and be sent as forced laborers to Germany to work on fortifications.

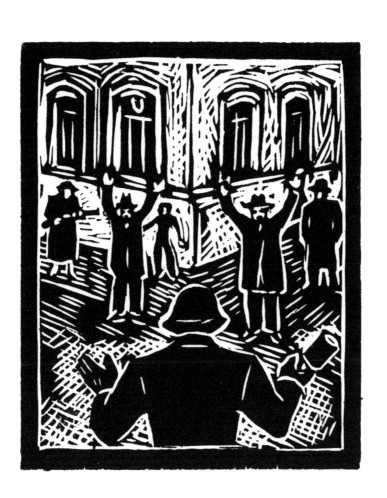

A gentleman from Tønsberg called me today. Since we did not know each other, we agreed to meet at the entrance to Norske Alliance. I went, but he did not appear.

A month later I got the answer. Another man came before me and introduced himself as Albert Jærn. It was the German painter Hirschel Haag, a member of the Gestapo. I know that my telephone has been monitored.

51

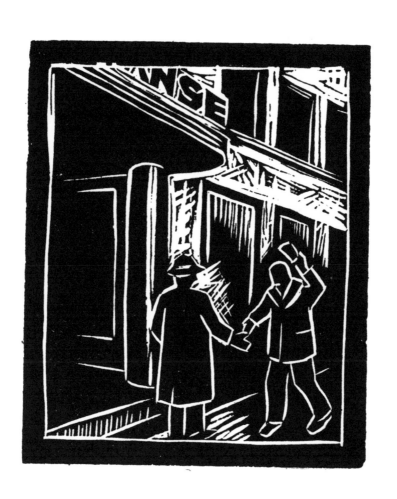

My wife is overly nervous and in need of sleep. For the most part she is awakened by dreams. This evening she woke up after she dreamt that she had been buried in a bomb shelter. Myself, I sleep like a log. I wake up more easily from the sound of a car motor than an airplane. We know the sounds even in our sleep. We use alcohol to sleep and Bensafinyl to stay awake.

52

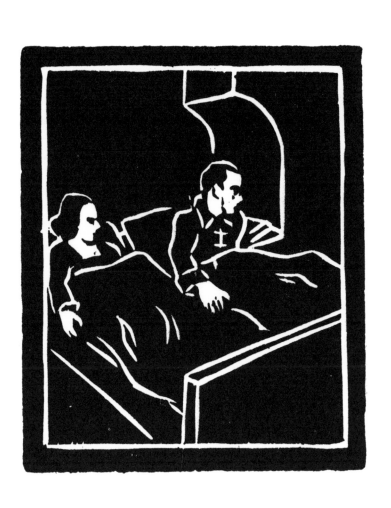

My younger daughter received a telephone message that there had been attacks on girls going to their workplace, so now it has come to sleeping away again. Good night! It is getting harder and harder to capture slave labor. Our department of information is becoming completely effective.

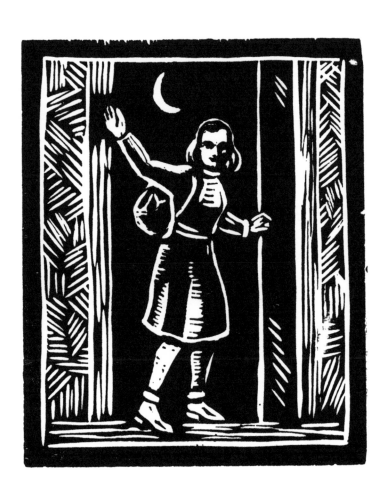

I believe that of all the hardships the blackouts are the worst, and the lack of fat has made me night-blind.

 54

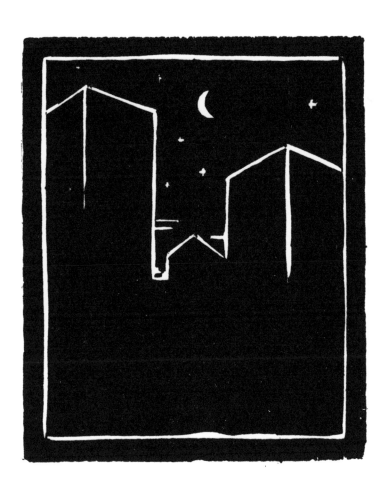

Civilian Nazis and the *hird* have for a long time assaulted people on the streets and removed the national pins and flags from their lapels.

Now they have started to take clothes from the children, mainly the red *nisseluene*.

55

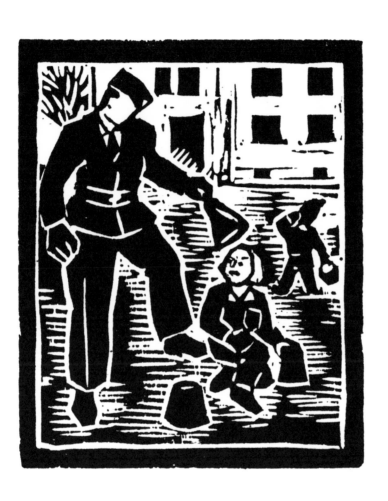

Today I took a trip to Tryvannsstua. The *hird* were undressing both the adults and the children. They take everything that is red: caps, sweaters, scarves, mittens, and socks.

The *hird* are armed, and there was one who was a little shorter than the rifle he was holding. It would have been amusing to know what his papa was called.

56

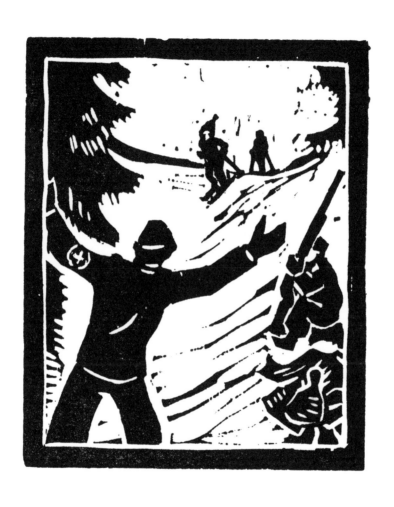

Our boys, who fled to the woods to escape forced labor, are so cautious that it is difficult to get in contact with them. Today the men who were taking them food, clothing, and rationed goods came back without meeting any of them. Some farmers get 3 kroner for a liter of milk and 5 kroner for a loaf of bread.

57

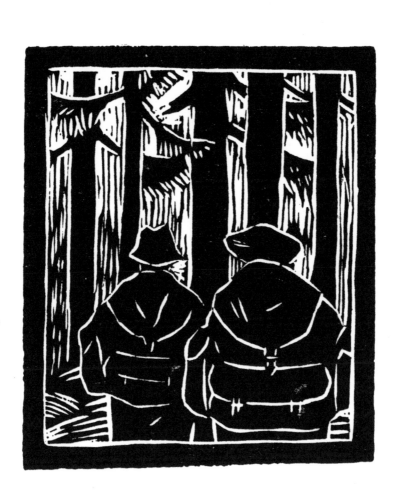

December 19, 1943. It was a beautiful sight when the explosion started, but the reality was frightening. Grenades, iron support beams, bricks, yes, even corpses were scattered over large parts of the city.

58

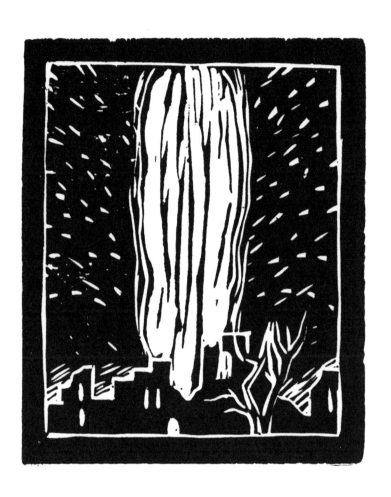

Then the apartment buildings started to burn. Hundred of homeless people who had lost everything they owned fled in different directions away from their houses. Only the heat and the ruins were left behind.

59

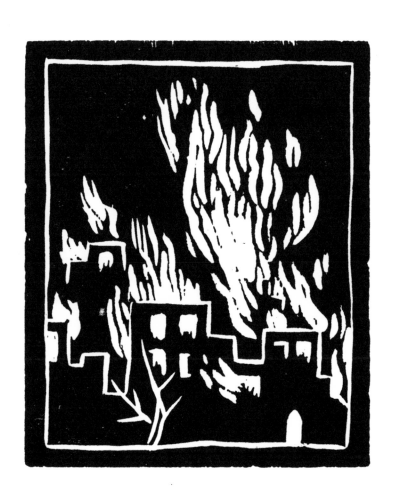

Nothing happened to us other than our dinner and dishes were ruined. The doors and windows that blew out were insured. After the boiler exploded, it was rather cold for a while.

60

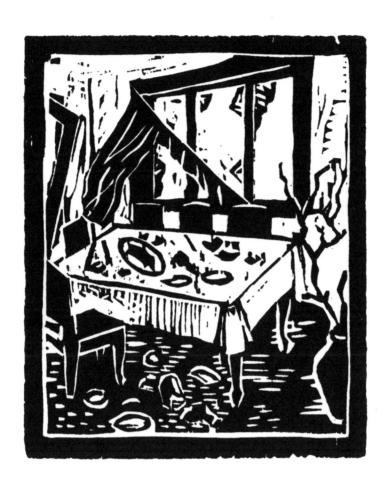

Several weeks after the explosion a green uniform jacket hung from the top of a tree at Mogens Thorsen Stiftelse.

I think of the advice: "Don't let children play with matches."

61

The Germans march daily through Storgata and sing that they are going to England. They carry pails of herring. I don't understand why they are taking herring to England. I wonder if they are going on leave and taking food illegally out of here.

 62

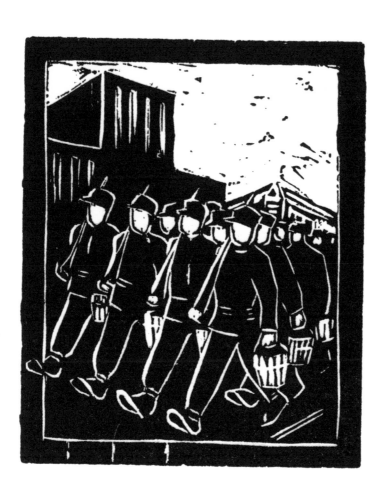

We came from the new theatre and went into a restaurant to eat. Then I saw a guest being beaten by a fighter from the front because he would not give him his cigarette.

Helten from the eastern front ran off before the police came.

I don't think that the guest will survive after losing so much blood.

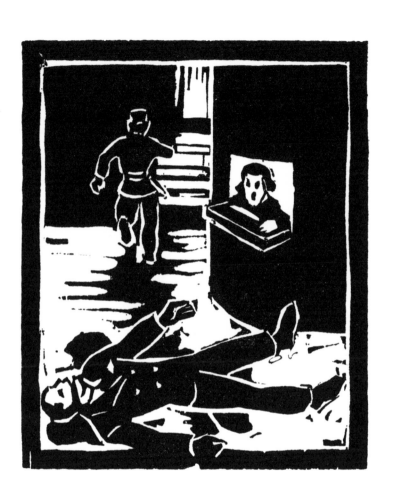

There is barely a wall in Oslo that is not covered with posters urging people to help the Germans. So, if someone broke into my home, am I to help throw out the police when they come to arrest the intruder?

64

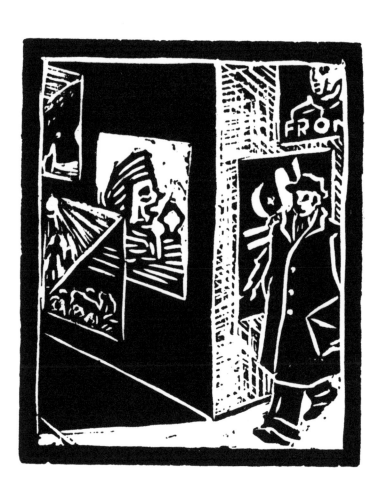

Fall 1943. At one o'clock at night a policeman came to summon us to something new known as *Borgervakt*.

At the same time he told me he had not eaten for eleven hours, I offered him a sandwich. There is always something to be learned this way. He told me the reason for the citizen-watch was this new form of terrorism against the Germans. An attempt had been made on the railroad tracks and it was blamed on *jøssingene*. When I acted as if I doubted this, he said, "We inspected the railroad tracks, and when we found an explosive charge we notified the Germans so that they could get rid of it. The German who came right away laid his head down on the device and listened to hear if a timer had been set. One doesn't do that if he does not know when the timer will go off."

65

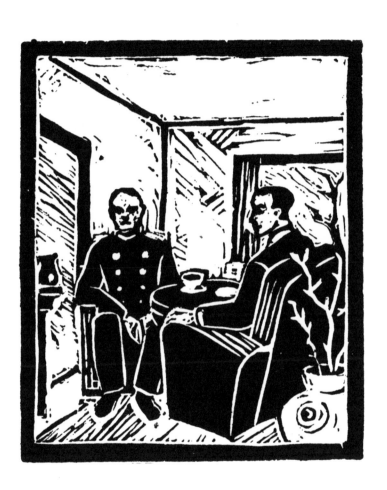

So exciting—there are lights in the street! But then it was only a plane that had gotten lost in the dark. If only it would happen every evening.

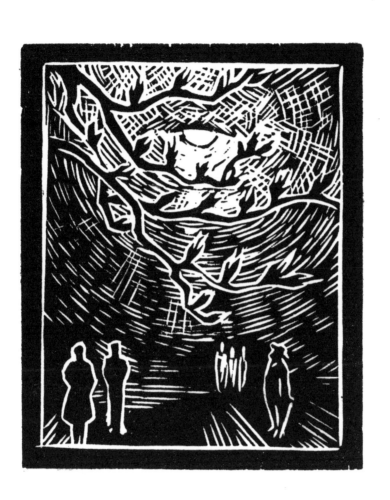

Today a prisoner fled from the Gestapo and jumped from the Victoria Terrasse down on Russeløkk Road. Several shots were fired at him. Did the Gestapo think that the man would continue to flee after falling from a height of twenty meters?

67

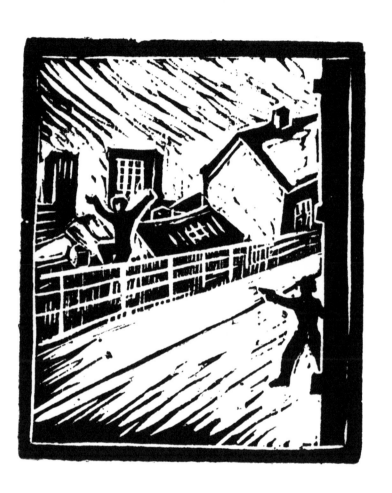

Egon Friedell, the Austrian historian and scientist who wrote *A Cultural History of Antiquity* and dedicated the book to Knut Hamsun, jumped out of the window when the Gestapo came. People jump off the Victoria Terrasse to escape the Gestapo interrogators.

68

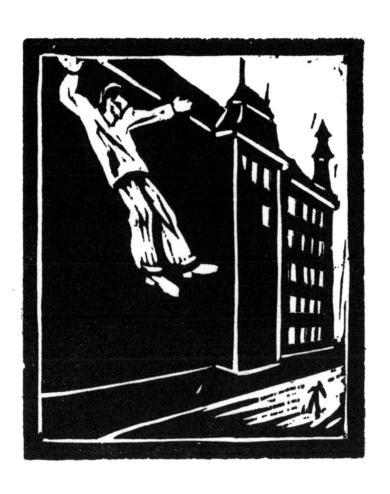

If there are guards on the steps or at the gates, the saboteurs will climb up to the roof. They always find a way.

69

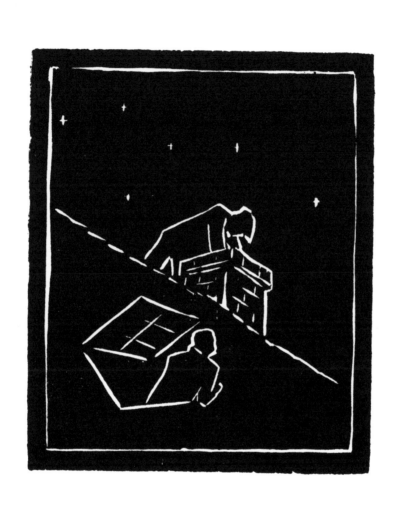

The saboteurs are gone.

70

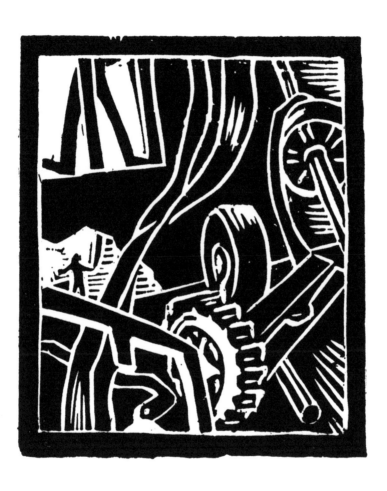

August 4, 1944. This is the most moving birthday I have ever had. My wife and I came home at midnight and sat outside in the garden with the neighbors until four in the morning.

From the homes nearby we heard Russian and Norwegian music while the moon cast violet shadows on an orange wall. There was no war to be found in the air.

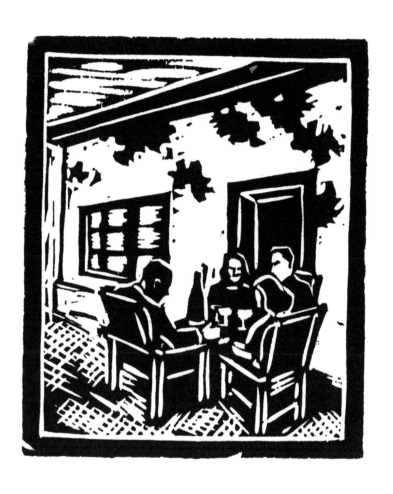

Quisling's teacher had good results in his garden, with tobacco and vegetables, but one morning the tobacco plants were torn in pieces. He decided to stand guard the next night, but did not do it. That night there was a knock on his garden gate, but no one opened it. The next morning there was not a vegetable plant left.

When he found out that nothing like it had happened to the neighbors, he said that the destruction must have been of a political nature.

72

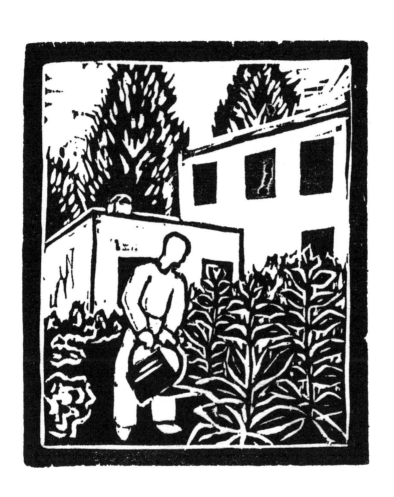

Today I met Joas. He had come home after three months detention at Grini. He said that the Germans had to stand guard over the food for the pigs so that the prisoners would not eat it.

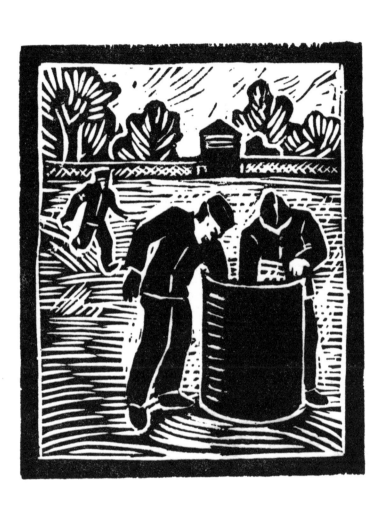

There is talk of a lot of brutality, and it is un-
believable, but eyewitnesses tell of a drunken
German officer who ordered some Jews to fall
right on their stomachs, without breaking the fall.
Afterwards the officer went from head to head,
while the Norwegian whores watched ...

The newspapers report every day that the Rus-
sians shoot from behind ...

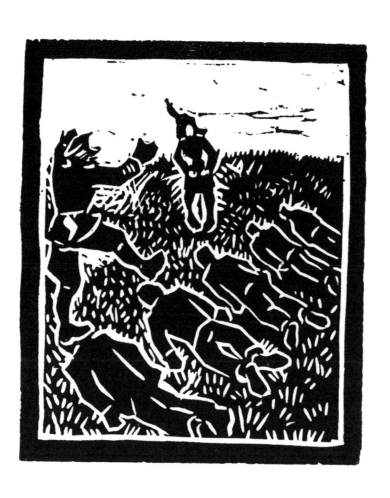

The *Statspolitiet* "captured" slaves for the Germans at Gimle theatre today. This reminds me of the Negro chieftain who sold his own people to the slave merchants.

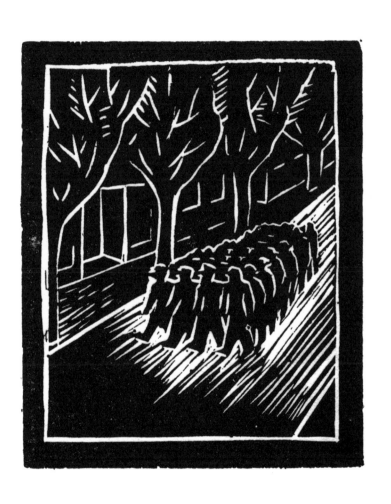

Ragna's mother was buried today. Fewer were in attendance than I had expected, but maybe some are in England.

It is strange to be at a funeral without a single relative. She got her last resting place right near a crossroad.

76

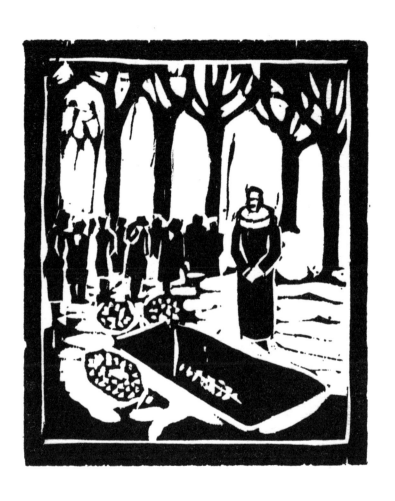

We would have a strange outlook on the war if we did not have our underground newspapers and other articles to enlighten us.

There was an article in *Aftenposten* about three English planes that were shot down over the southern coast, but there was nothing about the convoy of fourteen German ships that was attacked. Only one ship was still afloat when the attack was over.

77

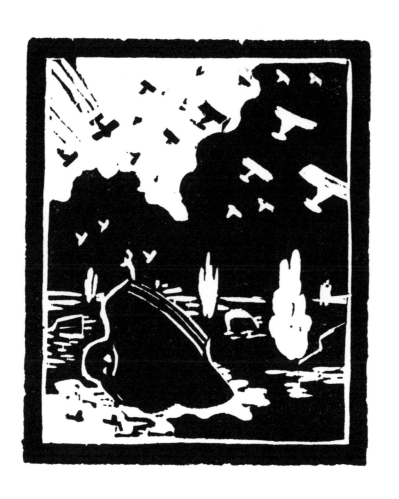

Nasjonal Samling probably believed that old saying that the man grows with his position when they appointed Edvard Stenersen, the Ox, son of the milk deliveryman from the Tveten farm, as the governor. His need to show off became obvious when he took four million kroner from the rich in Aker, but isn't that unlawful ...

Well, well, for the time being he still has his milk wagon.

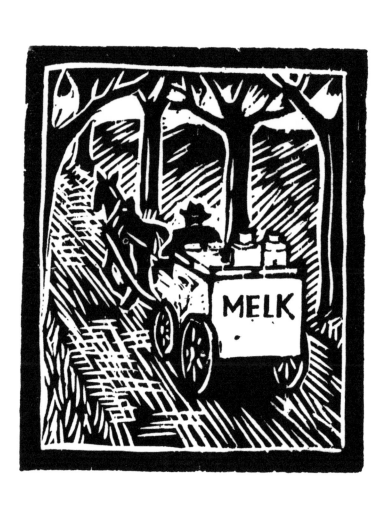

Today my older daughter and son-in-law along with our grandchild left us. They couldn't take it any longer. His paper has been prohibited and he has been working so hard in many ways. He is sick and tired. It will be sad not to see Monemor for a long, long time ...

People flee the city because of lack of food and fear of execution, *Nasjonal Samling*, and the Germans.

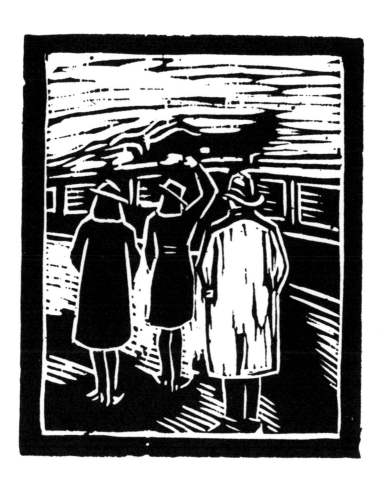

Now the disabled Germans are starting to come. The more that come, the closer we are to freedom. Freedom, yes, here we work for forty to fifty years to bring up our children and secure the future, and then these madmen come and destroy everything in a short time. They call themselves politicians, leaders, and God knows what. They give speeches and get others to follow, they get weapons and direct the masses, and they themselves have gotten promises of becoming nobility. And they end up with wooden legs, and a hook instead of an arm and so forth. And some can't even see what they have done. The first year of the war I planted potatoes, but the year after I planted roses. I must have a greater need for beauty than for potatoes. But I didn't get them to grow either.

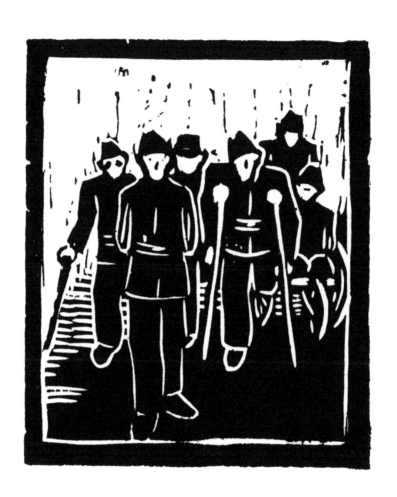

Heltene went out to take land from others, but the land took *heltene*.

According to oral tradition, it is called "the German burial-place at Ekeberg"; now it will be the new *"Ribbentrop."*

81

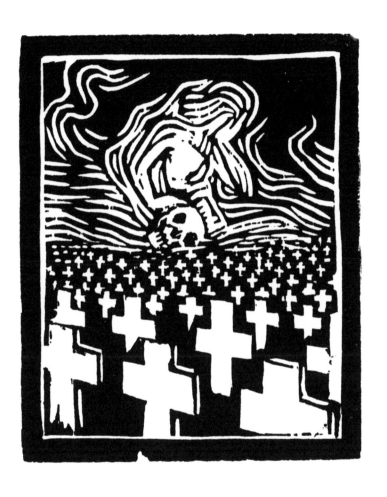

After traveling all day people came to Oslo in the evening without being able to get a trolley or a taxi. An old man who was being admitted to the Rikshospital had to walk from Vestbanen railroad station all alone. He had never been to Oslo.

A family that I met had a two-and-a-half-year-old baby and two large suitcases that they had to carry several kilometers.

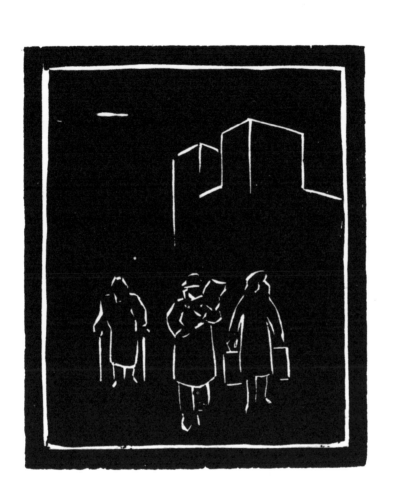

On our way home from a party this evening we had to go through a checkpoint. Nothing happened. We had been warned ahead of time, and we warned everyone we met.

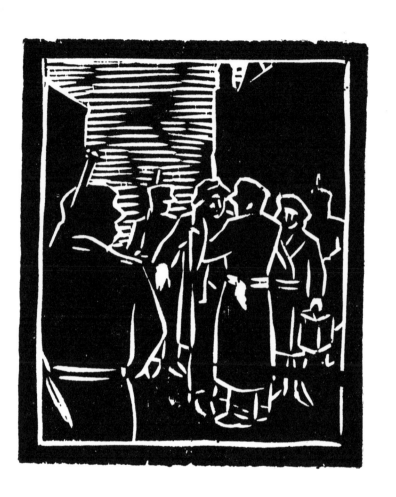

Christmas 1944. The package with food from Sweden made Christmas a celebration for us.

84

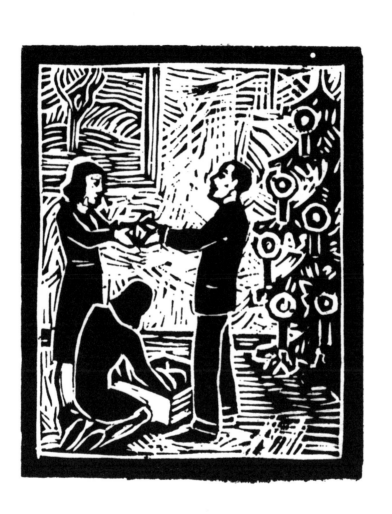

New Year's Eve 1944. About 11:40 an English plane flew over the city. The weather was beautiful, and the Germans fired after the airplane—then a great crash was heard. And then the air-raid sirens went off.

85

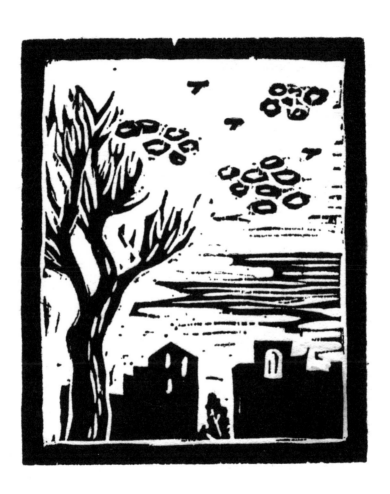

A streetcar was blown to bits and thirty-two Norwegians lost their lives. The smell of blood could be detected from far away, and corpses were found with blown out eyes and lungs. Others were torn to pieces. I was told that an old man who was standing some distance away was left wearing only his collar and shoes.

86

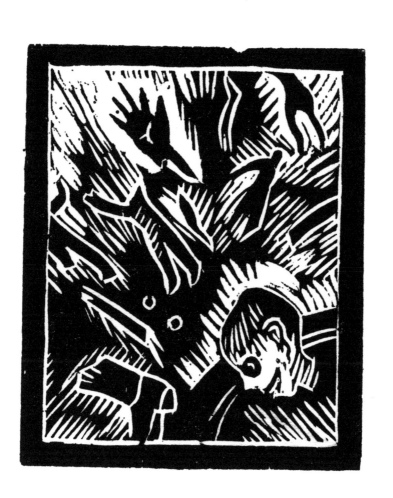

People flocked together to see the damage that was done to Victoria Terrasse. It was easy for the Germans to recruit the workforce here. And that they did. The Germans always avenge themselves on the civilians when they can't count on their military.

87

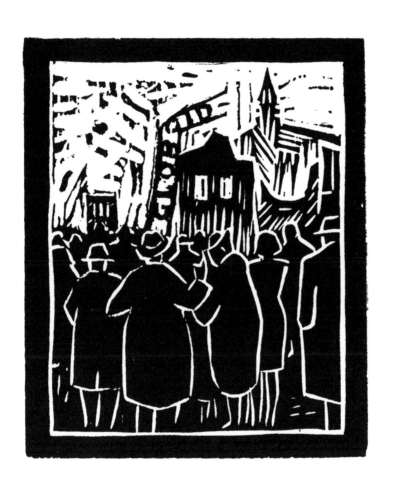

We had not heard from Per in three months. Today he came home. He had been detained at Voland prison in Trondheim the entire time, mistakenly thought to have blown up a locomotive at the Orkla mines. Per had been confined almost the entire time in a dark single cell without a change of clothing or a chance to really wash. He has mange, and large bald spots.

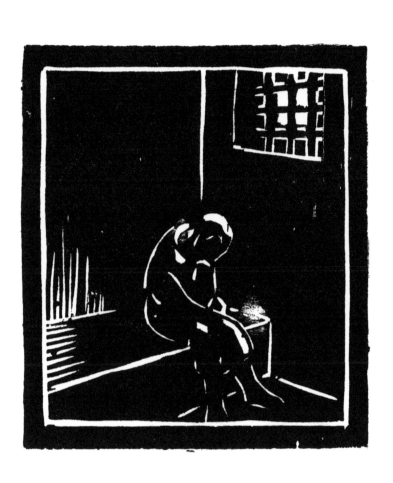

Per was here again today to have a little smoke. He is going over Kjølen to Sweden in the morning to report for police duty. Before he left Per said, "I want to leave, I have to avenge the ones who hang people from their feet and whip them with straps, or break their fingers to get them to admit to things that they most likely have never done." I know that Per has worked the best he could for our people, but the Germans will have no proof of this because, luckily, tomorrow he will be in safer hands.

Welcome home again, Per!

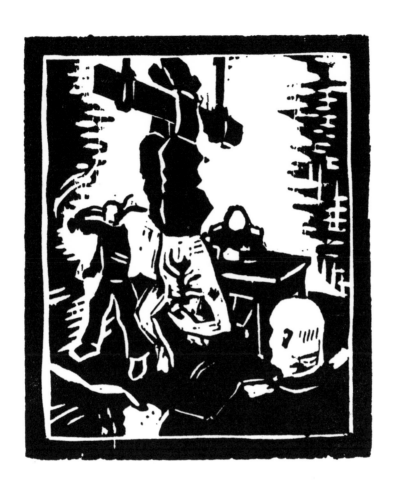

When I saw a clothesline of laundry today, I thought about the family whose boys could go outside only one at a time because there was only one pair of shoes.

A factory supervisor that I talked to could not change his shirt because the last one he had could not withstand another wash.

90

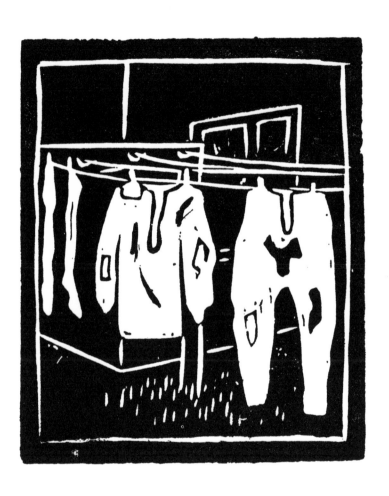

I have had great joy from my secret cabinet.
Twice my house has been searched, and it was not
discovered. Now I have all my woodcuts secured
there. It should be safe if it doesn't get bombed.

91

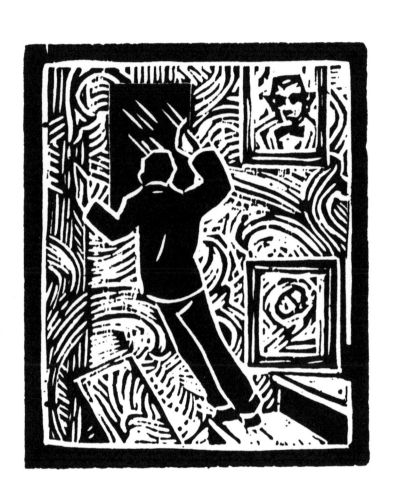

From a letter from Finnmark: "The Germans came up to the summer pasture when they saw that the homes in the valley were empty. We had been there for two days when I had the baby. Mamma was the midwife. Two days later the Germans came with search dogs and found us. There were over forty of us in the shack, and we were chased out. Then they set fire to all of the pastures. We had to go back to the coast again. I was so weak when I came down that I could barely move. And to think, they set fire to my home, and I was not allowed to go back in again."

92

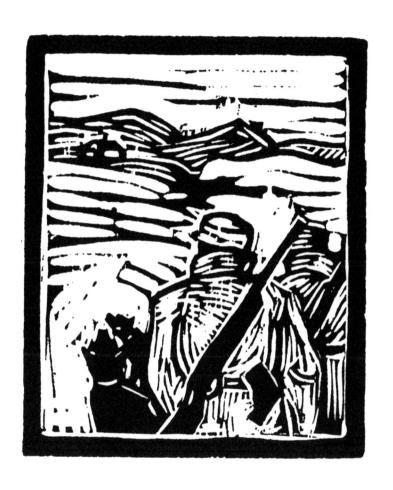

From another letter from Finnmark: "And you know, the Germans forced us with weapons to get on board the boat, which was already fully loaded with soldiers and ammunition. They thought that the boat would not be attacked when we were on board. We had to stay on the deck the entire time, and the baby who was only four days old could not be taken care of and not even washed. In other places people were more fortunate. They left in fishing schooners, forty to sixty people in each boat."

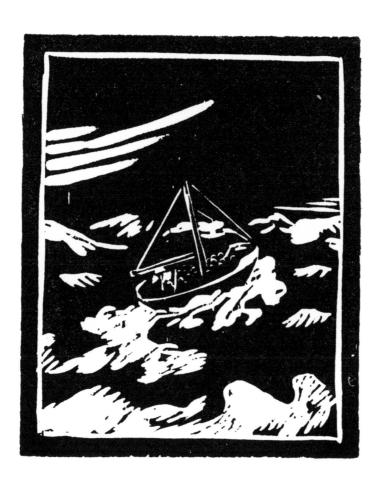

From another letter from Finnmark: "On the plateau they have scorched everything, and reindeer were shot from airplanes."

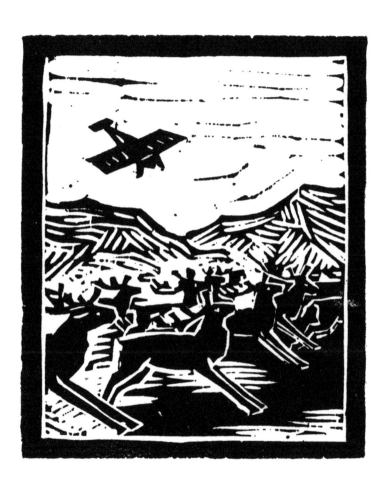

A couple of years ago the evening paper, *Aften-posten*, wrote that it was not necessary for adults to get milk, because all the nutrition in the milk the cows got from the plants. Why not then go further and say that we have no need for vegetables, because all of the nutrition in vegetables came from the soil and the air.

Eat dirt and drink air—live simply, there is so little now. Believe in propaganda.

I have been very weary and tired lately. This morning I discovered that I had a rupture. The doctor said that it was common because of the diet.

95

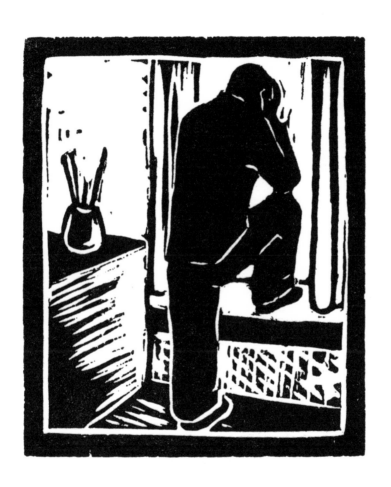

Now the Germans have barricaded themselves behind rolls of barbed wire. The guard has hand grenades along with his other supplies. It is not safe to go out after dark. Explosions go off unexpectedly.

 96

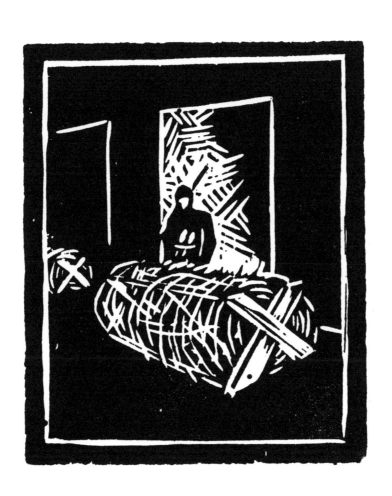

Our buildings become more and more vandalized. They are reconstructed into fortifications. Today when I came to the city for my tobacco rations, the shop had been turned into a fortress.

97

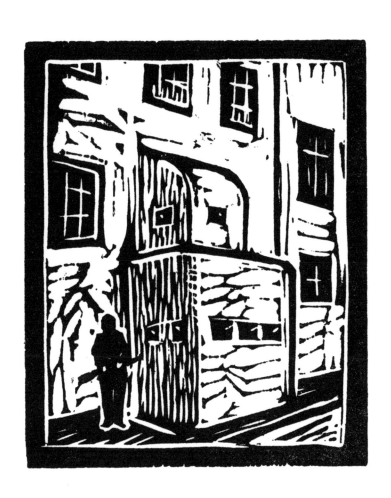

Eight days have passed since we met at the Restaurant Bagatelle and heard the first rumors of peace. There were congratulations and toasting to the new era that is coming. Since then the rumors have continued, despite denials.

98

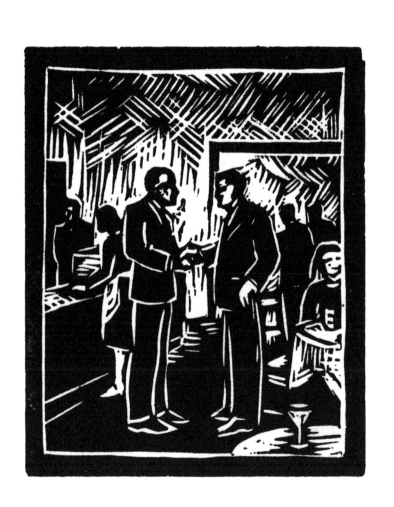

May 2. The Führer has fallen. The newspapers are writing that his actions will be remembered for a thousand years. Yes, we can hope. The editorial in *Aftenposten* said, "Adolf Hitler stepped forward during his people's hardest and darkest time, when chaos and anarchy had brought them to the brink."

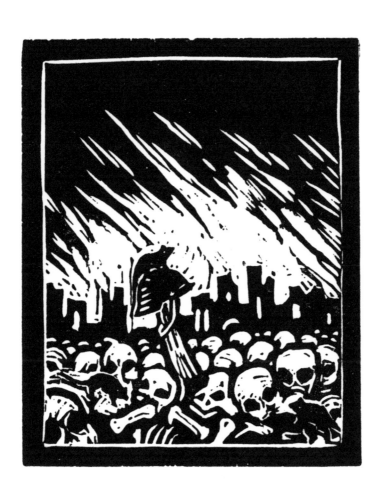

May 5. Quisling is giving a speech to the Norwegian people. He will continue the fight against the Bolsheviks. That is how it is now. It matters not to him if he has to offer more lives of the young. He is childless, so he has no connection to the future. He has always been an active person from the time he made the attack at the Ministry of Defense many years ago until today when he has to end the fight against the patriots who now for the first and last time have patience to listen to his voice on the radio.

100

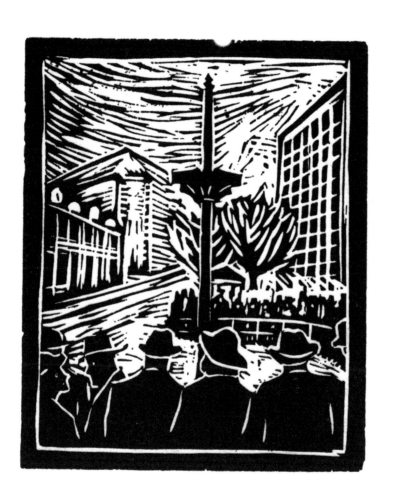

Denmark is free!

It is almost impossible for us to hang on any longer. Can't the doors be opened and the peace dove be permitted to fly here too ... This is dangerous. We are getting angry, we forget ourselves and speak out loud now and then, but it is going well because the Nazis are staying away.

101

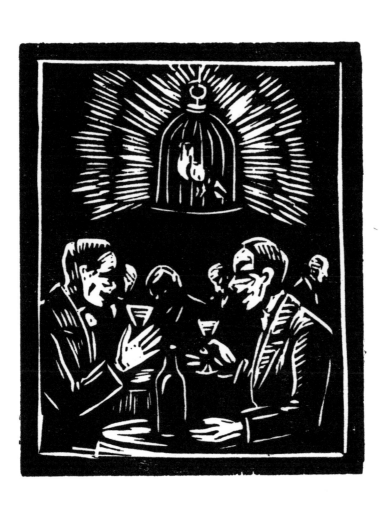

Monday, May 7, 5:45 p.m. PEACE, PEACE, PEACE, it is not to be believed. It is a feeling that I have never felt before. I am not only happy, I am delirious. I see people crying. I understand and I don't understand. There are flags all over. God only knows where they are coming from. The first flag I saw was on the university library, since then they have popped up all over. It is a sea of color, red, blue, and white. Something strange must have happened. I pinch my arm, yes, I am alive, I am awake—and I have permission to speak out loud.

102

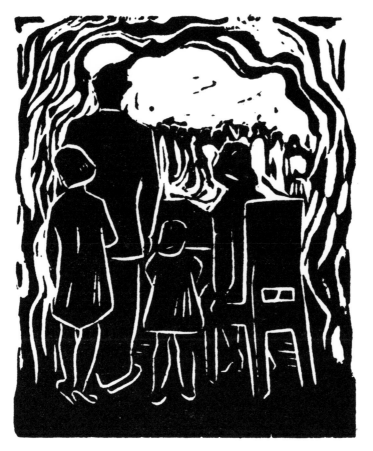

Heltene are leaving, the table has been cleared.

ALBERT JÆRN

Albert Jærn was born on August 4, 1893, in Kristiania. He was baptized Albert Marinius Jensen, but took the name of Jærn when he decided that he wanted to be an artist and designer. By the age of fourteen, he was working as an apprentice for his father, who was also an artist and designer. In 1913 he started working for a book printer, and it was there that he was first inspired to become an illustrator. In 1924 he delivered his first illustrations to H. Asche-houg Publishing Company, and through the years he designed over 500 book covers for them. Designs in India ink were his specialty, but woodcuts and linoleum cuts were also close to his heart, as demonstrated in his daybook *And Then Came the Liberators*. Albert Jærn died on October 9, 1949, at the age of 56.

GLOSSARY

Aftenposten: "Evening Post," Oslo newspaper with national circulation.

Blücher: German battleship sunk in the Oslo fjord by Norwegian guards at Oscarsborg fortress, near Drøbak.

Borgervakt: Citizen-watch.

Christian Qvart (1577–1648): Founder of the modern city of Oslo, known in his honor as Christiania / Kristiania from 1624 to 1925.

fred: Peace.

Fritt Folk: "Free People," Nazi party newspaper.

Hamsun, Knut (1859–1952): Norwegian Nobel Prize laureate in literature (1920), subsequently despised as an outspoken Nazi sympathizer.

heltene: The heroes.

herrefolket: The master race, nobility, aristocracy.

hird: Armed guard of the Norwegian Nazis.

hyrden: The good shepherd, play on the word *hird*, used ironically by Jærn to refer to the Nazi pastorate who replaced ministers who too openly opposed Nazism.

jøssingene: The patriots.

Kjølen: Mountain range between Norway and Sweden.

kulturfolket: The civilized people.

mil: European mile, 6.2 American miles.

Nasjonal Samling (N.S.): Official name of Norway's Fascist Party.

nisseluene: Knitted stocking caps, usually red.

Norsk Arbeidsliv: "Norwegian Labor News," Nazi newspaper.

Quisling, Vidkun (1887–1945): Founder of Norway's Nazi Party, whose name came internationally to signify "collaborator with one's country's enemies."

Ribbentrop, Joachim von (1893–1946): German foreign minister.

Ribbentrop: A pun based on the German foreign minister's name to give a purposely grisly image of the burial grounds at Ekeberg of the German soldiers.

Statspolitiet: State Police.

svartebørs: Black market.

Svenska Norgeshjälpen: Swedish Aid to Norway.

UFA: German film studio.

AFTERWORD

ALBERT JÆRN AND OCCUPIED NORWAY

BY KATHLEEN STOKKER

You have just read a remarkable document. Its very existence could have cost the life of its creator, had it been found by the Nazis. For in its bare-boned simplicity, Albert Jærn's account captures in words and woodcuts the atrocities and indignities Norwegians experienced during their country's five-year-long occupation by Hitler's forces.

Albert Jærn (1893–1949) was born and lived his relatively short life in Norway's capital city, known since 1925 as Oslo. He worked as an illustrator for Aschehoug, a well-known publishing house, where he also produced the cover art for some 500 books. Yet he is best known for the 447 bookplates he made in a format similar to the illustrations in this wartime diary. Jærn favored blocks of wood or linoleum and simplified lines and surfaces, free of affectation or exaggeration. He stands out for his originality and his ability to capture precisely the point he wished to convey.

Even before the German invasion of Norway on April 9, 1940, Jærn had a sense of lurking danger. During a three-week auto trip through Germany in 1937, he witnessed a leader who "loved cannons" and "a people who would rather have cannons than butter," as he reported in his diary. When war did come to Norway, Jærn was only forty-six years old. By no means a household name, Jærn nevertheless managed to keep his art alive all through the occupation by expressing in woodcuts his trenchant observations of the everyday acts of war.

Keeping this record put Jærn in great personal danger, but he apparently felt compelled to do so. He scrupulously hid this work away in a secret cabinet, which went undiscovered by the occupiers despite repeated Nazi raids and ransacking of his home. After peace came to Norway on May 8, 1945, Jærn made excerpts of the diary available to 200 subscribers, who received them on May 17,

Norway's Constitution Day, an annual celebration whose meaning the newly re-won freedom made uniquely precious. Later that year, Jærn's son-in-law, Egil Ekko, published the diary excerpts on his own press, Ekko Forlag (which had been shut down by the Nazis during the occupation). The present volume is an English translation of that 1945 publication. Perhaps it was at the time of publication that Jærn's diary got its title. Burning with anger and seething with sarcasm, it plays on a major tenet of Nazi propaganda, namely, that the occupiers had come to free Norway from certain invasion by the British.

The original audience for Jærn's book had personally experienced or was otherwise well acquainted with the events Jærn depicted. Since then, however, the generation who knew them has fallen away and many details of those years have been forgotten.

Jærn published his diary in the hope that his countrymen would "never forget" their ordeal. He wanted Norwegians to remember their own confusion and fear as well as the enemies' tyranny and oppression. This afterword aims to provide a context for later generations to understand that ordeal and to appreciate Jærn's art and artistry in preserving it.

Before dawn on April 9, 1940, Hitler's soldiers invaded several Norwegian coastal towns and cities, whose citizens awoke to find German soldiers in their streets. Hitler planned a similar attack on Oslo, but the sinking of the battleship *Blücher* in the Oslo fjord at Drøbak (some twenty-two miles south of Oslo) severely delayed it. Killing an estimated 600 of the soldiers prepared to invade Oslo, the sinking also enabled Norway's king, Haakon VII, to elude capture.

Later dubbed the "king who said no," Haakon VII famously refused German orders to collaborate with the Nazis and, while

traveling east to the town of Elverum, became the target of Nazi bombs. Air attacks relentlessly traced his path as he continued his journey north and west to the arctic town of Tromsø.

Unprepared for armed combat, Norwegian military forces had to surrender on June 10 after two months of fighting. At about this time, King Haakon and his government ministers began their escape to England. Through mine-infested waters they crossed the North Sea and subsequently established in London Norway's legitimate government in exile and in protest to the Nazi regime that had taken charge back home.

Two months earlier, on the evening of the April 9 invasion of his homeland, Vidkun Quisling made his way to the national broadcasting station (NRK) in Oslo. He announced to his fellow citizens that they must give up all resistance to the German soldiers who had come "as friends" to "help" and "protect" Norway from British attack.

Quisling founded Norway's Nazi party (*Nasjonal Samling* or NS) in 1933, the same year Hitler came to power in Germany. Quisling lacked the hypnotic charisma of Hitler, however. Nor did his country face the extreme challenges of Germany, which needed to repair its damaged reputation and ruined economy after being found guilty by the Treaty of Versailles of war crimes. Most Norwegians, therefore, remained unmoved by Nazi ideology (especially its promise of world domination), and did not join the Nazi Party in sufficient numbers to support even a single seat in *Stortinget*, the Norwegian parliament.

Norway had gained independence in 1905, a mere thirty-five years before the German invasion. Because the nation intended to live in peace, there was little political will to invest in armaments.

When the king and some government ministers called for more spending on munitions during the term of prime minister Johan Nygaardsvold (which began in 1935), their urging fell on deaf ears. Aiming to narrow the enormous disparity in living standards between Norway's wealthy and working classes, Nygaardsvold prioritized social reforms instead. Quisling and other descendants of moneyed families found the new social measures distasteful and rejected them as communism.

Quisling also viewed with alarm the growing number of Jews seeking refuge in Norway from oppressive regimes in Eastern Europe. Aiming to solve these "problems," he applied for and received an audience with Hitler in 1939. Quisling suggested to the *führer* that Norway would better be able to address these issues under Nazi rule, and he requested Hitler's help.

Hitler had his own strategic reasons for invading Norway and neither informed Quisling of the attack nor assigned him a role in it. When he saw that Quisling could not garner widespread cooperation from the Norwegian people, moreover, Hitler sent one of his own trusted leaders, Josef Terboven, to be the power behind Quisling's puppet regime.

The "new Norway," as Quisling dubbed his regime, featured several institutions based on Hitler's Germany, most notably the *Hird*. The word goes back to the Viking period (ca. AD 800–1000), when the hird was a circle of warriors and advisors close to the king. Both the NS and Hitler found inspiration in this golden age of Norwegian history and freely used Viking imagery in their ideology and propaganda. Quisling's party, which proclaimed its unique ability to restore to Norway her former greatness and power, applied the term "hird" to its own counterpart of the German Storm Troops

and Hitler Youth. With time, "Hird" came to signify several military style subsections of the NS, including organizations for women and children. As Hitler's war fortunes failed and the Hird found it increasingly difficult to recruit adult members, witticisms flourished depicting the Hird with peach fuzz on their cheeks, still in grade school, or (as does Jærn) barely big enough to carry their guns.

Along with fear and confusion, the April 9, 1940, invasion brought strict censorship of all Norwegian radio and newspapers, the principal mass media of the day. Public meetings were forbidden, as was listening to radio broadcasts from the BBC in London. A daily Norwegian-language program was beamed toward Norway at 7:30 p.m., to tell the Allied side of the war. BBC broadcasts denied the barrage of reports that glorified German victories, exaggerated Allied defeats, and depicted King Haakon as the runaway ruler who had deserted his country in its hour of greatest need.

The Nazis freely spread their ideology in the censored press (such as *Aftenposten*, Norway's largest newspaper), as well as in party-sponsored papers such as *Fritt Folk* (free people) and *Norsk Arbeidsliv* (Norwegian labor news). The Nazis began by making it illegal to listen to the London broadcasts, and when that didn't work, they confiscated the Norwegians' radios, starting with the Jews in May 1941, and continuing with the rest of the population in September.

Since Norwegians were required to register all radios at purchase and to subsequently pay an annual license, the sets were easy to trace. Yet a surprising number of Norwegians somehow managed to hide one. A few took the even more dangerous step of copying the "illegal" broadcasts. These they transcribed and typed up and, after making as many mimeographed copies as they dared, spread

them as the so-called underground press. Getting caught during any stage of this operation would reliably lead to imprisonment and unspeakable torture.

Established journalists also found ways to resist, often by sneaking anti-Nazi messages into the censored mainstream press. Jærn's son-in-law apparently did this, and like so many who took this chance and found their papers outlawed, he needed to make a hasty escape.

Robbed of their newspapers and radios, Norwegians found life dreary—and quite literally dark. Compulsory *blending* (window blinding) brought rude knocks on the door from gruff Nazi guards if they spotted light leaking from a window after dusk. To avoid fines, wartime Norwegians learned to cover all windows with impenetrable black shades. They also had to find their way through darkened streets devoid of guiding lights or headlights from the few passing cars. The Nazi-imposed precautions were said to "protect" Norway from nighttime attack by the British, who might be searching the landscape for illuminated targets to strike.

Even the movie houses no longer offered their welcome escape. Adding to the constant sense of danger and imprisonment, each performance now began with a compulsory propaganda film, the so-called UFA (Germany's principal film studio) week in review. When Norwegians tried to avoid this film by not taking their seats until it was over, theaters were ordered to stop advertising the start time of the UFA film, and to require that patrons be seated before any part of the evening's presentation began. Police guards enforced these orders, and when patrons showed their displeasure (or, says Jærn, simply sneezed, coughed, or shuffled their cold feet), the guards turned up the lights and sent the entire audience home.

Adding to the Norwegians' annoyance was the common sight and sound of German soldiers singing through the streets that they were on their way to England. *"Wir fahren gegen Engeland,"* they intoned, conjuring up the terrifying image of an attack, which would likely have radically changed the way the war in Europe eventually ended.

Amid such nerve-wracking conditions, how were average Norwegians to behave? The organized resistance sent instructive *paroler* (directives) by way of London radio and underground press. The resistance advised "good Norwegians" to show occupiers the "cold shoulder." Refuse to sit beside German soldiers at the movies or on the streetcar, give them misleading directions or false information to even the simplest questions. Better yet, say "I don't know" in English, as the diary shows Jærn, a "faithful listener to London," did while living at Brandbu in Hadeland, where he and his family briefly relocated in the wake of the April 9 invasion.

Did the Nazis have other clues to Jærn's anti-Nazi sympathies? Whether with good grounds or none, the Nazis arrested Jærn on June 20, 1941, at the home of a friend. The Nazis simultaneously interrogated Jærn's wife at the family's home in Oslo. When asked if Jærn received any newspapers, his wife calmly named the Nazi papers one couldn't help but receive (and which, says Jærn, usually ended up as fish wrap). Meanwhile, one of the couple's two daughters left to take a walk, discreetly taking along the underground newspapers the family did receive and actively read.

Jærn could not escape the long interrogations and imprisonment the Nazis routinely imposed for even the slightest of "crimes." For this purpose, the Nazis established a network of prison camps throughout Norway. By far the best known was Grini, a large

facility located in the Oslo suburb of Bærum, which came to house a number of Norway's foremost intellectuals. Jærn tells of the horrendous conditions at the Voland prison near Trondheim, where his friend Per endured torture and contracted scabies or mange, a parasitic skin disease induced by filthy surroundings.

By comparison, Jærn was lucky. Imprisoned near the Oslo suburb of Grorud at a facility named Bretvedt, he was released after only a few days. Upon his release, he noticed a strange thing: people spontaneously helped him in unexpected ways, apparently seeing in him a fellow citizen subjected to Nazi torment. What a contrast to the atmosphere of distrust and uncertainty he had found upon his return to Oslo from Brandbu during the first few weeks of the occupation!

Those who slipped Jærn fine food and drink recognized in him a fellow *Jøssing* (a "good" or "patriotic" Norwegian, i.e., one of decidedly anti-Nazi sympathies). The term originated as a Nazi slur (for the "cowardly" Norwegians who had liberated British POWs from the German battleship *Altmark* in the Jøssingfjord near Stavanger in February 1940). Once battle lines were more clearly drawn in the wake of the April 9 attack, Jøssinger adopted the term as a badge of honor, redefining it as those who actively worked to restore Norway as it had been before the invasion.

Jøssinger advertised their views by wearing symbolic clothing, such as the red stocking cap. Known as a *nisselue*, this was the cap worn by the *nisse*, or farm gnome, a figure that had become a symbol of Norwegian identity during her period of national discovery in the decades following the adoption of the constitution on May 17, 1814. Jøssinger also wore paperclips (*binders* in Norwegian) to signify binding together against Nazism, wristwatches face

down to declare down with the "new time," and combs protruding from pockets to denote the Norwegians' ability to *greie* (manage; comb) themselves without the "help" of the occupiers. In time their most unifying symbol became King Haakon's royal monogram, H7. Scratched along ski trails, knitted into mittens, worn on coins around their necks, and etched into every available surface, Haakon's monogram celebrated his own unequivocal no to Nazism.

Jøssinger had also begun to celebrate the king's August 3 birthday. Jærn mentions the demonstration that took place on that date in 1941. The organized resistance had probably sent a directive that "good Norwegians" should mark the day by wearing a flower and thereby "tease" the Nazis. Seeing a golden opportunity, marketplace vendors laid in a good supply, then beckoned customers to buy their "teasing flowers."

The 1941 demonstration paved the way for the even larger and more famous one that marked the king's next birthday. On that occasion a great majority of Oslo's residents wore flowers to honor the king—and found themselves promptly arrested. Remembered as the largest show of anti-Nazi sentiment of the entire war, the 1942 demonstration made headlines far outside of Norway.

What had happened to sharpen the fronts during the year between these two birthdays? Certainly citizens were angry over food shortages and their consequent poor health.

Given Hitler's plan that the occupied countries would have to feed the occupying soldiers, there were bound to be shortages. Norway housed 300,000 occupying soldiers, a number equal to one-tenth the country's wartime population. Meanwhile foodstuffs and other supplies from her usual trading partners, Britain and Denmark, were cut off by the war.

To deal with the shortages, Jærn, along with many others, engaged in the black market. As early as April 1940, he tells of buying a load of potatoes in Hadeland and selling them to various neighbors in Oslo in order to feed his own family. The Nazis (and Norwegian war profiteers) increasingly gave this practice a bad name, selling at usurious prices foodstuffs they could obtain at little or no cost, and pocketing the difference. Jøssinger avoided being their dupes by developing an internal *byttehandel* (barter system), trading what they had in surplus for what they needed.

Others profited from the occupation by joining the Nazi Party to receive favorable treatment, whether personally or financially. Most hated among these were the women who romanced the Nazis. Though some of these couples developed genuine relationships, many simply took advantage of each other. Whatever the nature of the relationship, the women involved were universally despised and degradingly dubbed *tyskertøs* (Germans' whores). Even Jærn's Nazi-leaning apothecary neighbor seems gravely taken aback when Jærn reports having seen his daughter in the company of a German soldier.

Not satisfied with monopolizing the women and the food supply, the occupiers took over Norway's finest homes and most significant public buildings. Quisling used the royal palace as his headquarters, Terboven occupied the residence of the crown prince's family at Skaugum, and the glorious landmark known as Victoria Terrasse (now home to Norway's foreign department) housed the sadistic Nazi police force known as the Gestapo. Most of these private homes and public buildings sustained serious damage in the process, whether from brutality or carelessness. School buildings suffered, too, as those not damaged in bombing raids were also taken over by the Nazis for their own purposes.

Though many of these indignities took place earlier in the occupation, nothing had prepared Norwegians for the terror unleashed on September 10, 1941, with the "disgraceful" (Jærn's term) executions of Viggo Hansteen, age forty-one, and Rolf Wickstrøm, twenty-nine. Labor leaders, they had helped instigate the so-called milk strike, whose purpose was to protest the Nazi-induced food shortages. Outraged by the strike, the Nazis declared martial law. They court-martialed both Hansteen and Wickstrøm and immediately executed them to deter further acts of defiance. Sending shock waves throughout Norway, these executions significantly sharpened the division between Nazi and Jøssing.

Jøssinger began protesting more boldly, augmenting their symbols with actions ranging from sabotage to simply defacing the Nazi posters that had come to monopolize every public space. With radios confiscated, posters became the primary means of spreading Nazi ideology. One theme dominated: Norwegians could help their country best by supporting the Nazi cause. "Norwegians," one poster implored, "Fight for Norway: Join the Waffen SS," i.e., fight on Hitler's side against the Allies.

Hitler had invaded the Soviet Union in June 1941, in direct defiance of the anti-aggression pact drawn up by foreign minister Joachim Ribbentrop and signed by both countries. In the wake of this ill-fated attack, the Nazis banned all Norwegians from wearing red clothing. Seeing it as a show of sympathy with the Soviet Red Army, they especially confiscated the red stocking caps and threatened strict punishment to all wearers, including the parents of the many children who wore them.

Nazi posters urged Norwegians to fight on the Eastern Front against the Soviets. About eight thousand Norwegians registered to do

so, and somewhere between five and six thousand actually saw war-
fare. Those Norwegians who did not become soldiers were expected to
do their part by turning in their blankets, rubber boots, backpacks,
coins, and other metal, all to support the anti-Soviet battle which, as
Jærn points out, Norwegians never asked for and didn't want.

Posters also pressed Norwegians to join the seemingly more
benign work service *(arbeidstjeneste)*. An outgrowth of a movement
that started in several western countries during the 1930s, such
organized service (like the WPA in the United States) aimed to put
the unemployed to work doing socially beneficial tasks. Norwegians
had instituted a voluntary work service earlier in 1940, but after
September (when Terboven declared the Nazi Party Norway's only
legal governing body) it came under Nazi control.

At first, all males (later females, too) nineteen years of age were
urged to register for this service. Before long, registration became
compulsory. To counteract this development, the organized re-
sistance reported, via London radio, that the work registry was
actually a tool to secure young people as soldiers and nurses for the
Eastern Front. The resistance therefore directed young people to
avoid registering for work service by all means possible. This advice
proved prophetic. Jærn tells of Nazis surrounding a nearby apart-
ment building and arresting the young male residents. His daughter,
having gotten word of a similar raid, went into hiding.

Like Jærn's daughter, many young people avoided registration
by concealing themselves. For some, this meant leaving Norway
altogether. Though escape presented its own serious challenges, the
necessity resulted in several often-reliable methods. One, the so-
called Shetland Bus, consisted of a series of fishing boats that would
arrive from Britain to drop off trained resisters and equipment

for the Home Front (Norwegian-based resistance forces) and then return to Britain, bringing escapees, many of whom received training from the SOE (Special Operations Executive), Norwegian forces headquartered in London.

A considerable number of Norwegians escaped compulsory work service by hiding in Norway's vast wilderness. *Gutta i skauen* (the boys in the woods) became a significant part of MilOrg, the military arm of the Norwegian resistance. This body, which initially trained the new arrivals, would later bomb the building in downtown Oslo that housed the registration cards of those who had been forced to sign up for work service.

(Jærn's diary notes an earlier explosion, which rocked Oslo on November 19, 1943. Said to be one of the greatest wartime catastrophes to befall the capital city, the explosion at Filipstad wharf took place at 2:45 p.m. as the Germans unloaded the munitions ship *Selma* shortly after its arrival from Denmark. The blast killed forty-five Norwegians and seventy-five Germans. It also destroyed 800 tons of ammunition and 405 buildings, effectively leveling a fifteen-acre area in the neighborhood. Suspecting it to be an act of internal sabotage, the Germans took no reprisals.)

Others needing to escape Norway crossed to Sweden over the challenging mountain range known as *Kjølen* (the keel), for its resemblance to an overturned boat. Sweden managed to remain neutral during the war and, as such, gave assistance to both sides. It allowed free passage of Nazi soldiers and of Swedish iron ore for their use, while also offering safe refuge and support for Norwegian refugees from the war. Like Britain, Sweden provided, moreover, resistance training to the Norwegian escapees. Jærn tells of Per joining the Swedish Police Force, as this resistance group was

known. It would later play a major role in the liberation of the Norwegian province of Finnmark. Sweden also became a safe haven for some 50 percent of Norway's Jews, while most of those who were rounded up and deported to Nazi concentration camps perished.

Sweden assisted Norway in many other ways during the occupation, not least by supplying food to Norwegian schoolchildren. The Nazis focused their message on young people and aimed to inject their ideology into textbooks and curricula. They also filled the many vacant teaching positions caused by the invasion with teachers of their own persuasion.

Resistance grew during 1941, however, so that the NS requirement in February 1942 that teachers join the Nazi Teachers Union met with steadfast refusal. Teachers rejected especially the demand that they sign a declaration promising to instruct their pupils in the "new spirit." The occupiers responded to the teachers' "defiance" by closing down all schools in the Oslo area, leaving the teachers to hold class in less suitable locations.

On March 20, 1942, Quisling had 1,100 teachers arrested and sent to Norwegian concentration camps. When the teachers continued to refuse Nazi demands, 500 of them were shipped off to North Norway, first by cattle car to Trondheim, and from there by boat to Kirkenes on Norway's border with Russia. Crammed onboard the small steamer *Skjerstad* (capacity 250), all 500 teachers and 50 guards traveled for thirteen days. Though their suffering ultimately did cause many to nominally join the teachers union, most continued steadfastly to refuse the demand that they indoctrinate their pupils in Nazi ideology.

Located in Norway's arctic north, Kirkenes, along with the rest of Finnmark, would eventually be the first part of Norway to see

the occupation end. In the autumn of 1944, the Russians drove the German army, some 200,000 strong, into North Norway. Following Hitler's orders, the retreating Germans now used a "scorched earth" strategy on all of Finnmark, beginning with Kirkenes, which they destroyed on October 24. Moving south, they forcibly evacuated on short notice the 40,000 inhabitants of Finnmark. Those who chose to stay behind concealed themselves in caves or hid in the primitive huts of the *seter* (mountain dairy-grazing pasture), which the soldiers also burned down, as Jærn reports.

Jærn personally observed another sign that the end was near: the disabled German soldiers from the north arriving in Oslo. Seeing them, he couldn't help but pass along one of the many jokes that flourished during the occupation. Punning on the name of Foreign Minister Ribbentrop, he reports that the burial place at Ekeberg would soon hold the German dead, henceforth to be known as the *Ribbentrop* (skeleton corps).

At last Jærn could write of the last days of the occupation as seen from Oslo. On May 2, 1945, the Nazi-controlled newspaper *Aftenposten* carried Hitler's obituary. While its author praised Hitler for taking action during his people's darkest and most difficult time, Jærn's woodcut for the date offers quite a different assessment of Hitler's legacy.

On May 5, British forces commanded by field marshal Bernard Montgomery liberated Denmark. In Norway, meanwhile, Quisling addressed the Norwegian people with the promise that he would continue to fight. He thereby raised the specter then haunting the Allies: What might happen in a Norway still occupied by more than 300,000 undefeated German soldiers?

The commander of the German garrison in Norway, General Franz Bøhm, wondered, too, and was also ready to continue the

fight. So when he heard on May 7 that at 2:41 a.m. the German army had officially capitulated in Reims, France, he found the news hard to accept. Not until 9 p.m. did he receive his own orders from Nazi headquarters in Flensburg. Reluctantly concluding that he and his troops must obey, he announced his decision on Norwegian radio one hour later, at 10 p.m. And so it was that as of shortly after midnight, total capitulation had come, also in Norway, with plans for the German soldiers to be marched across the border for internment in Sweden.

Though the peace didn't become official until May 8, Jærn and others couldn't help celebrating early. Jærn tells of Norwegian flags flying all over town by 5:45 p.m. on May 7. Many had spent the last few hours repairing their beloved banners, suddenly legal at last, after five long years of Nazi-imposed disuse!

Can we even imagine the relief Jærn must have felt to realize that his words and woodcuts had at no time fallen into enemy hands? Still safe in the secret cabinet, his precious and perilous account could no longer be used to threaten his life. May you, the reader, also revel in Jærn's sardonic view of his country's World War II occupation by the Nazis, the self-identified "master race" of "cultured" "heroes" who "came as friends" to "liberate" Norway.

Solveig Schavland is a researcher and translator at the Norwegian American Genealogical Center and Naeseth Library in Madison, Wisconsin. She is the author of the memoir *Leaving Norway*. She was born in Stavanger, Norway, on the day of the occupation.

Kathleen Stokker is Professor of Norwegian and Director of Scandinavian Studies at Luther College, where she has taught since 1978. The co-author (with Odd Haddal) of the Norwegian language textbook *Norsk, nordmenn og Norge* (1981), she has also written *Folklore Fights the Nazis* (1997), *Keeping Christmas: Yuletide Traditions in Norway and the New Land* (2000), and *Remedies and Rituals: Folk Medicine in Norway and the New Land* (2007). For her work in strengthening ties between today's Norwegian Americans and their ancestral homeland, Stokker received the St. Olav Medal (2005) and a private audience with King Harald V.

Richard Quinney is author of several books that combine autobiographical writing and photography, including *Journey to a Far Place, For the Time Being, Borderland, Once Again the Wonder, Where Yet the Sweet Birds Sing, Of Time and Place, Field Notes, Things Once Seen,* and *A Lifetime Burning.* His other books are in the field of sociology. He has established Borderland Books as an independent publishing house of crafted books. He lives in Madison, Wisconsin.

Design: Ken Crocker
Editorial Assistance: Diana Cook
Production Consultant: Della Mancuso
Printing: Capital Offset Company
Binding: New Hampshire Bindery
Typeface: Bodoni BT
Paper: 100 lb. Finch Fine Text

Frontispiece: Albert Jærn woodcut published in
the Swedish edition, *Så kom befriarna*, 1983